POSTCARD HISTORY SERIES

Galesburg
Illinois
IN VINTAGE POSTCARDS

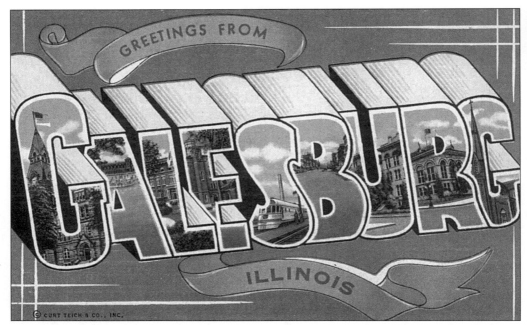

Greetings from Galesburg. The welcome mat is out in the 1940s, and Galesburg, Illinois, sends greetings to the world on every postcard. This common postcard design, the "BIG LETTER" card, includes, within the letters, images of the courthouse, Old Main, the Zephyr, Lake Storey, and Main Street. The images tell the whole story. Galesburg is a town with strong institutions, recreational possibilities, commercial and transportation potential. The town has whatever anyone might need. Galesburg is a place to call home.

Postcard History Series

Galesburg Illinois
in Vintage Postcards

Carley R. Robison

Copyright © 2000 by Carley R. Robison.
ISBN 0-7385-0762-8
First Printed 2000.
Reprinted 2001.

Published by Arcadia Publishing,
an imprint of Tempus Publishing, Inc.
3047 N. Lincoln Avenue, Suite 410
Chicago, IL 60657

Printed in Great Britain.

Library of Congress Catalog Card Number: 00-105298

For all general information contact Arcadia Publishing at:
Telephone 773-549-7002
Fax 773-549-7190
E-Mail sales@arcadiapublishing.com

For customer service and orders:
Toll-Free 1-888-313-2665

Visit us on the internet at http://www.arcadiapublishing.com

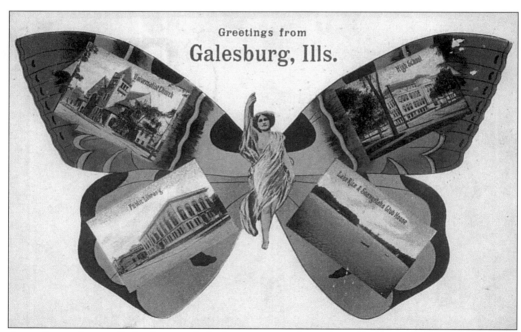

Greetings from Galesburg. Galesburg wanted to let all know about her public institutions, her religious influences, and her fun-loving side. This postcard mailed in 1909 pictures the Universalist Church, the public library, the Galesburg High School, and Lake Rice, with Soangetaha Club House a speck in the distance. The turn of the century was a time of great change and prosperity in Galesburg. Locals missed no opportunity to promote the town.

CONTENTS

Acknowledgments		6
Introduction		7
1.	Greetings from Galesburg	9
2.	All in Good Hands	15
3.	This is the College City	27
4.	Taking Care of Business	41
5.	Where the Railroads Cross	61
6.	Sundays in Galesburg	73
7.	Having Fun—Wish You Were Here	87
8.	Main Streets—Your Streets	97
9.	Galesburg Is the Place To Be	113
Index		127

ACKNOWLEDGMENTS

Grateful appreciation goes to Charles Bobbitt, author of two Peoria, Illinois, postcard books (*Peoria, A Postcard History*, Arcadia Publishing, Charleston, SC, 1998; *Peoria, Illinois, Revisited*, Arcadia Publishing, Chicago, IL, 2000) for all his positive conversation and advice. Thanks to the Lake County (Illinois) Museum, and Curt Teich Postcard Archives for permission to use their images. Thanks to Charles and Rick Lipsky for the use of postcards from their collections, and to Mrs. Neva Fach, William Raia, and the Knox College Archives for use of their images. To the staff of the Galesburg Public Library, and those thoughtful and encouraging people I work with at the Knox College Library—thank you.

Thanks to Laurie Sauer for her kind words and indexing, and Zach Narus for his exceptional computer skills. Appreciation goes to readers and advisors Bill Franckey and Terry Wilson, and to Bonnie Niehus, Kay Vander Meulen, and an army of Ace Archives Assistants for taking up any slack. Thanks to Trish Hattery for helping, as she so often does, to improve my point of view, and to Ginny for her memory and insight. The award for understanding and patience goes to Phillip.

Finally, we—all of us interested in local history—owe a debt to the men with the cameras: Allen Green, F.E. Augerson, Walter Peck, Charles Osgood, Charles Fach, and all the other men and women. Great gratitude goes to those who took photographs of our town and what was happening here. Some photos were made into postcards and are included here. Some are preserved at the local libraries, and others are yet to be discovered. The photos tell the story.

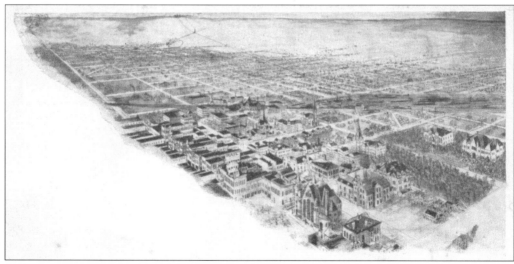

Galesburg from Above. This postcard shows Galesburg facing the southeast, with Main Street on the left edge of the image. Central Congregational Church is in the foreground. Across Simmons Street is Churchill School, and Old Main and Alumni Hall at Knox College are to the right, near Standish Park. The Chicago Burlington & Quincy rail yards are the shadow across the middle of the view. The date of the image is probably somewhere near 1902.

INTRODUCTION

Gathering these postcard greetings from Galesburg has been a labor of love. I grew up in Galesburg, moved away, and came back. I like Galesburg, and I like the stories that make up the history here. Over the years I collected bits and pieces of Galesburg history, postcards in particular. In the Knox College Special Collections and Archives, I work with history everyday. I thought putting together such a postcard history such as this would be a snap. Instead it was frustrating, hard work.

I wanted to tell too much and I wanted many more pages. I wanted to use all the postcards I could find! I had to leave out some of my favorites. Limiting the postcards and editing the captions was a monumental challenge. Often the decision had to be made to tell the story of the town or the story of the postcard. Sometimes the meaning behind the image on the postcard was the most important story.

In this "glancing blow" at Galesburg history, there was no room to tell about the first automobile race ever held in the U.S. (4 October 1899—Dr. E.V. Morris of Galesburg racing F.B. Snow of Peoria at the Galesburg Driving Park). Or about the only murderer hanged in Knox County (John M. Osborne, March 14, 1873, for murder, robbery, and rape.) Or the big strike that put Galesburg on the labor map (at CB&Q in 1888, murder and mayhem that lasted over a year). There were not enough pages to tell about Galesburg's part in the gold rush or the truth about the Ferris Wheel connection, or the Underground Railroad, or the socialist movement. There was not enough space to write about voting Galesburg "dry," the red-light district, the big Ku Klux Klan meeting, places like Boone's Alley and Monkeytown, people like Phillip S. Post and Mary Allen West, Gus Wenzelmann and Evar Swanson.

The result has been a kind of "Galesburg History Lite"—the low-calorie version, fluffy, full of the real thing, but not so heavy it'll slow you down. These postcard greetings from Galesburg may be pleasing enough, but it may just make you long for the full-bodied, richly-detailed, meaty story. My advice to you is to go right down to the library and follow up with a bit of real history. Both the Galesburg Public Library and the Seymour Library at Knox College have excellent collections of local history waiting for you.

There are classic Galesburg history books, of course. *They Broke the Prairie*, E.E. Calkins, Charles Scribners, New York, 1937, and *Missionaries and Muckrakers*, H. R. Muelder, University of Illinois Press, Urbana, 1984 are a good start. There are new views of old history being written every day and new classics in the works. The more the better. We need to tell the stories of our town. And there are so many stories.

The very short story of Galesburg history would start in Oneida County, New York, with a group of dilligent people of high moral character. A band of Presbyterian and Congregational settlers from New York came here in 1837 to start a town on the prairie where there was nothing at all. Buying as much of a section as they could, the settlers started a college following a plan established by George Washington Gale, an inspired and determined Presbyterian minister. Reverend Gale wanted to create a college to educate ministers who would spread the gospel on the prairie and into the world. The site for the college and the town was selected because of its natural resources, isolation, and affordability. Land purchased by the trustees at $1.25 an acre was sold to the colonists for $5 an acre. The profits would fund the college operations. George W. Gale brought with him 50 or so pioneering families including the redoubtable Silvannus Ferris and most of Ferris's grown children. Sylvanus Ferris was the major investor in the Galesburg enterprise, and his business acumen saved the colony from

disaster. The pioneering families brought a successful balance of idealism and practicality. The town built schools and churches, struggled, grew, and prospered. The college sustained itself and achieved national recognition for excellence. Knox College graduates have distinguished themselves in all fields of endeavor and continue to do so.

The community prospered too. Railroads came to town and brought a distinctive new flavor. Irish came to work the railroad, and much later Mexicans. Swedes came from Bishop Hill in Henry County. African-Americans came before and after the Civil War. Galesburg grew beyond the agricultural center of her beginning. For nearly 80 years Galesburg has been described in city directories as "a five-fold city—railroads, industries, agriculture, education and commerce—a most interesting and desirable city for those seeking a new industrial location outside the congested areas, where may be found greater satisfaction in operation from the standpoint of business and fuel, the great advantage of good transportation, facilities and sufficient supply of electric power furnished at comparatively reasonable rates, and a desirable community in which to live."

Over the years, Galesburg has been described as " The Ideal City" or "The Buckle on the Cornbelt." In the 1940s Galesburg was "The Hub of the Central Illinois." Recently Galesburg told everyone that she was a town "Pioneered with vision—geared to action." In any case, the message remains the same, and Galesburg is ready to spread the word. Galesburg is a town that is proud of her history and eager to share her potential. Postcards became a way to send out that message.

The heyday of postcard popularity was at the turn of the century. It was a time that was full of optimism and possibilities. Doors were opening. People were learning more and traveling more. Postcards were an economical way to keep in touch, but there was more. Postcards told the folks back home all about the expanding world. And likewise, communities generated cards to tell the world about themselves, both out of pride and for economic reasons. The glories of the town became a marketing tool. In many ways a postcard history becomes a record of what a town wishes others to see. A community was pleased to send out views describing the best of the town. Photos were taken of what the townspeople were most proud.

From our point of view a century later, these postcards become a kind of telescope back in time. We read the message and become part of the intimacy of a conversational exchange a hundred years old. The cards transport us to the street, the circus, the fire, or the space in time that captured the attention of the photographer. In a small way we are able to be in the scene. We are the history.

One
GREETINGS FROM GALESBURG

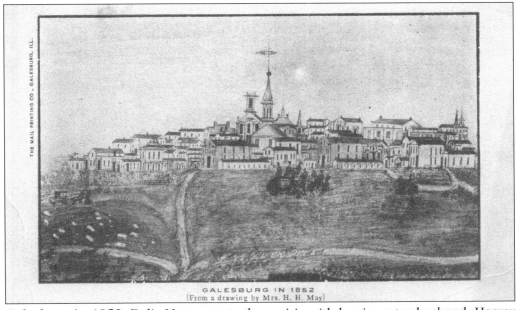

Galesburg in 1852. Delia May came to the prairie with her inventor husband, Harvey H. May, as an early pioneer. He went on to invent a self-scouring plow, and she recorded the image of Galesburg in 1852. In the image above, the little village of Galesburg was just 15 years old, but, clustered on a small rise on the prairie, it must have looked substantial. The spires and bell towers of churches and schools rise above commercial buildings and homes. Delia May's primitive drawing shows roads and travelers on their way to town, a testimony to the town's prosperity.

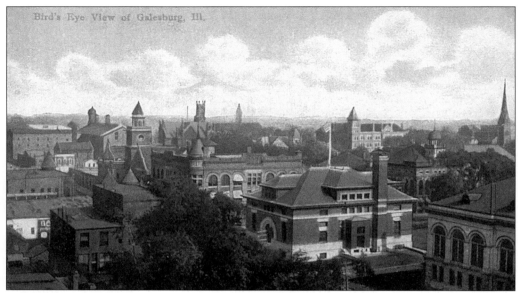

Looking to the East. This postcard looking east shows, in the lower right, the rounded windows of the public library. Beside it is the post office at Cherry and Simmons Streets. Across the street is the Brown's Business College building. Next to Brown's is the Central Fire Station with a bell tower and round window. The large buildings farther east belong to the Brown Cornplanter Works. Against the horizon on the right are Corpus Christi Church and Corpus Christi Lyceum. Far in the distance is the tower of the Chicago Burlington & Quincy (CB&Q) depot and the gothic bell tower of the Methodist Episcopal Church. The year is about 1910.

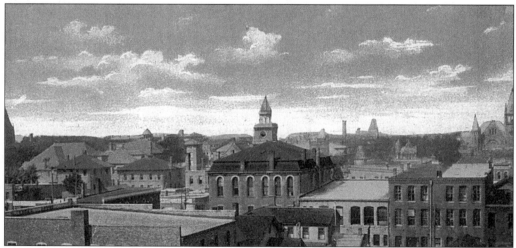

Looking to the West. This bird's-eye view of Galesburg, looking to the west in about 1910, shows Central Congregational Church on the horizon to the far right. Churchill School is the square tower in the distance. In the center of the view is the bell tower of the Central Fire Station, which faces Simmons Street. Although it seems to be part of the fire station, the square building with the rounded windows is actually located on South Prairie Street. The Knox County Courthouse appears to the far left.

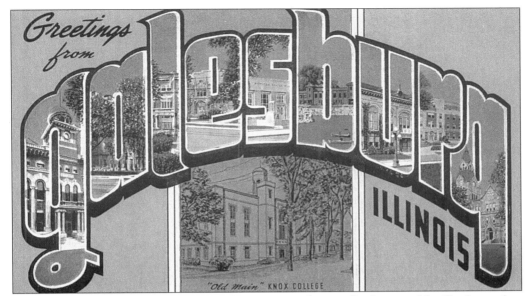

Greetings from Galesburg. Galesburg wanted to tell the world all about her assets—pleasure and potential. This card shows images of city hall, St. Mary's Hospital, the Galesburg Club, Seymour Library at Knox, the post office, Lake Storey pavilion, the public library, Cottage Hospital, and the Knox County Courthouse. A sketch of Old Main at Knox College is central to the card. About the time of this card in the 1940s, 20 passenger trains left the Santa Fe depot daily, and even more left from the CB&Q. Nearly 50 buses traveled in and out of town every day.

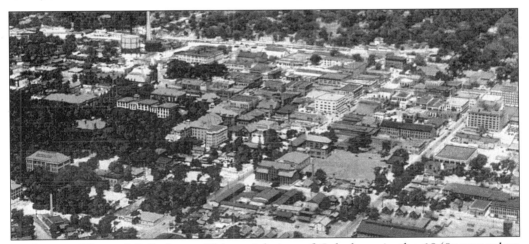

Bird's Eye View of Galesburg. This aerial view of Galesburg in the 1940s was taken from the southeast, looking toward the north residential area. George Davis Hall and Whiting Hall are emerging from the trees on the Knox Campus to the left. The former St. Mary's Hospital is the u-shaped building at near center, and the Hotel Custer (Kensington) is to the far right. The long building that remains from the Brown Cornplanter Works is near the hotel on Kellogg Street. The large open space in the center is the playing field behind Corpus Christi High School. The smokestack and holding tank of the gas plant can be seen near the Santa Fe tracks to the upper left.

Goats and Peas. Always ready to promote their town, correspondents were happy to send cards that made the most of local stories—fantastic or not. "This is the way we do things in Galesburg," would be the boast that accompanied such exaggerated images as this one. Photo manipulation in the darkroom made these kinds of postcards popular at the turn of the century. Publishers printed hundreds of cards like these and then added the name of the town on the front, depending on the possibility of sales.

Making Fun. Like the exaggeration cards, postcards such as this were generated by the thousands. Later the cards were then printed with the name of the town in which they were to be sold. The cards were usually illustrated with cute children, and the humor often centered on ethnic differences or carried messages in dialects. Most often the sentiment conveyed was "wish you would write" or "having a great time."

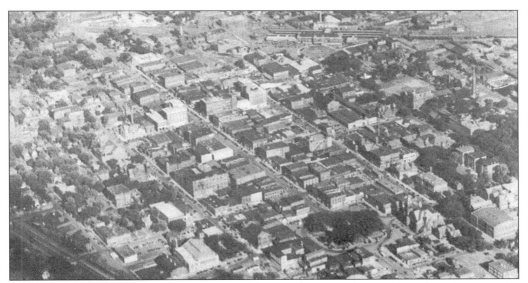

Galesburg from the Sky. This view is of Galesburg in the early 1940s showing the tree-filled Public Square at the lower right. Main Street cuts diagonally to the upper left corner, and the Santa Fe tracks are located at the lower left. Across the top of the image are the CB&Q tracks, and the depot is the dark rectangle near the center top. Galesburg went all out in the '40s to entice new businesses and industries, and postcards such as this were part of the campaign.

Galesburg is Ideal. This postcard sends a positive invitation to anyone who may want to see the town that made headlines in 1921. In that year, Edward Bok, the publisher of *Ladies Home Journal* from 1889 to 1919, announced that Galesburg was "the ideal American city, most desirable in which to live in this great nation. Ideal in its opportunities for real living for men, women and children." In small communities such as Galesburg, a person could find time for work, repose, and quiet thought—time to read and make neighborly contact. Edward Bok did not live here, but in 1920 nearly 24,000 people did, and Mr. Bok's evaluation was a source of pride for years to come.

Dusting for Galesburg. In the late 1920s, Galesburg boasted 95 miles of paved road and 100 miles of water mains. The telephone plant was described as being the acknowledged model in America. Galesburg had 600 acres of parks and 7,200 residences. According to one promotional publication, Galesburg had the largest gravity railroad switching yards, the largest horse and mule barn, the largest gate factory, the largest tie treating plant, and a factory making the largest cement pipe in the world. Overalls, casket hardware, automobile adjustable footrests, paper balers, and heating boilers were all produced here—not to mention "nearly enough brooms to sweep America." It's no wonder that anyone wanting to get to Galesburg would raise some dust!

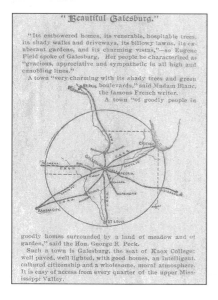

Beautiful Galesburg. Promoting Galesburg to potential businesses and residents alike was serious. This turn of the century map shows the railroad access to Galesburg. The quotes describe the town's beauty and possibilities. Eugene Field (1850–1895), a widely popular poet, spoke of our "embowered homes and venerable, hospitable trees." He knew Galesburg from the time of his colorful career as a Knox student in the 1870s, and 20 years later his comments made an impact. With charming vistas and intelligent, cultured citizens, the town was clearly an idyllic place.

Two
ALL IN GOOD HANDS

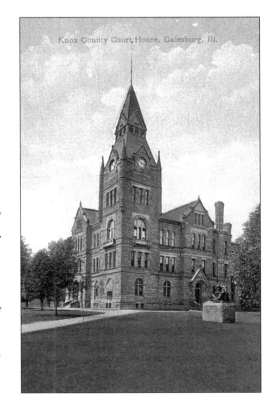

Knox County Courthouse. Built in 1886, the Knox County Courthouse was the visual result of a hotly contested battle for the county seat. After a highly emotional, and ultimately contested, election in 1869, the county seat was moved to Galesburg from Knoxville, where it had been since the development of the county in the 1830s. The courthouse was designed by E.E. Meyers (1832–1909), a Michigan architect who went on to design state capitols in Colorado, Idaho, Michigan, and Texas.

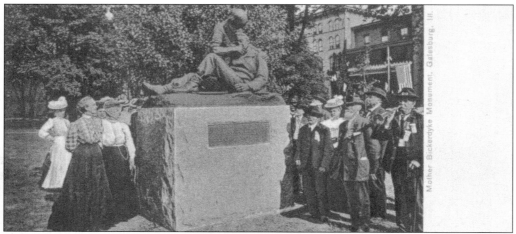

Mother Bickerdyke Memorial. Mary Ann Bickerdyke (1817–1901), first learned about the suffering of the Civil War soldiers one Sunday morning in church from Dr. Edward Beecher, who told of horrid hospital conditions at a Union camp in southern Illinois. A woman of great energy and determination, Mother Bickerdyke fought her own war with soap and soup. Her fearless determination and legendary resourcefulness made her the friend of privates and generals alike. When a junior officer complained about her to General W.T. Sherman, his response was to say, "She outranks me." Her accomplishments can only be described as valiant. This statue in honor of Mother Bickerdyke was created by the woman sculptor Theo Kitson, who unveiled it herself in 1906 on the courthouse lawn.

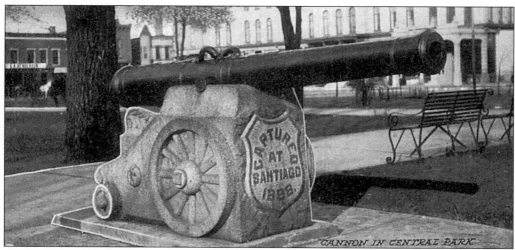

Spanish-American War Cannon. This eighteenth century cannon, which was removed from a fort in Santiago, Cuba, by American forces in 1898 during the Spanish-American War, was awarded to the local chapter of the Grand Army of the Republic. Through the efforts of the congressman from Galesburg, George W. Prince, the cannon was brought to Galesburg and was first placed in Central Park on the Public Square, "aimed" up East Main Street. A thousand people came to the unveiling ceremony there in February 1901. The cannon has since been moved to the north side of the courthouse lawn, where it is now "aimed" at Whiting Hall.

City Hall. Known now as Old City Hall, the building designed by local architect, William Wolf (1838–1906), was constructed in 1906 on South Cherry Street at a cost of $34,000. The building was faced with black chip Purington brick and raindrop sandstone. Offices of the mayor and other city officials were located on the first floor, and a large council chamber occupied the second. The dome was removed about 1916 and was not replaced. Galesburg Preservation Inc. received the property in 1994 after the municipal offices moved to the newly constructed city hall on Tompkins Street in 1991. The building is currently used for professional offices.

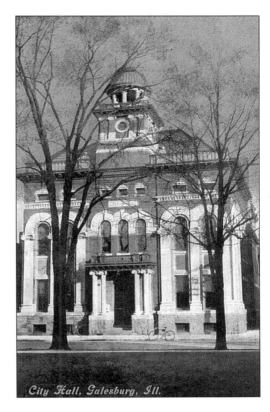

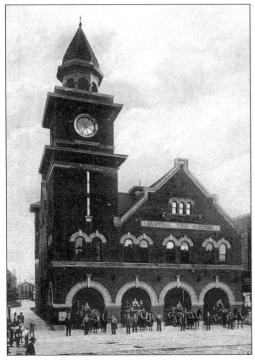

Central Fire Station. J. Grant Beadle (1865–1929), was selected as the architect for the new Central Fire Station, and construction was completed in 1906. The station included garages for equipment and horses, sleeping quarters, a library, a billiards room, and office space. Automatic doors opened when a fire alarm sounded, and the horses moved into position. The station became the final part of a three-building civic complex that included the police station and the city hall. In 1976, a new fire station was built as part of the Public Safety Building two blocks to the east. The Central Fire Station was converted to use as the Community Center.

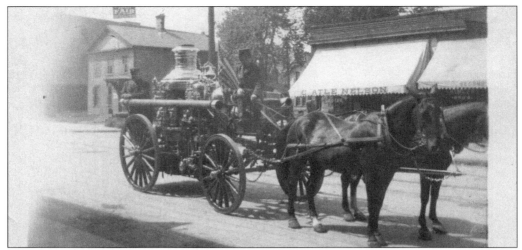

Fire Protection in 1914-Style. Fire protection in Galesburg was provided for many years by volunteer fire companies, with names like Good Will Hose, Tornado Engine Company, and Rescue Hook and Ladder—each one proud and competitive. The city consolidated services in 1878, but plans for the construction of a central fire station weren't initiated for nearly 25 years. This postcard shows firefighters pausing in front of C. Atle Nelson's grocery at 88 South Seminary Street.

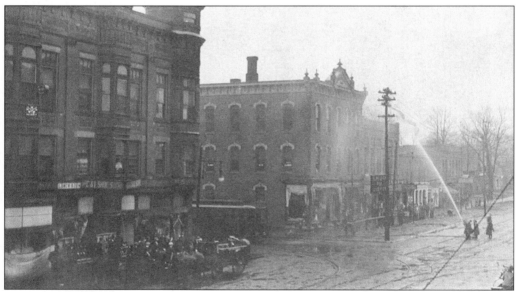

Fire on Main Street. Hundreds of spectators were drawn to great and disastrous fires, which occurred with relative frequency. This is an undated postcard showing a fire near the corner of Main and Seminary Streets. Photos of disasters such as this were common in the first decade of the last century, when many amateur and professional photographers produced real photo postcards straight from the darkroom. Still, it is rather disconcerting to see a dramatic postcard like this with a casual message on the back: "I baked three pies today even though it is hot. Irma down with a cold. All else fine. Love, Mother."

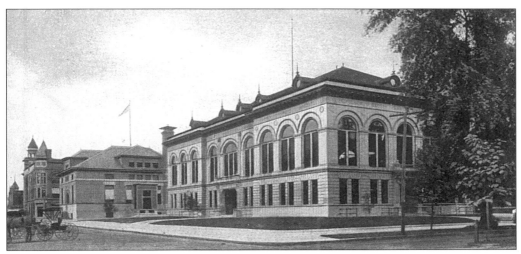

The Public Library. The Galesburg Public Library began as the Young Men's Literary Society, and for some years was operated in quarters above stores on Main Street. The Carnegie Foundation contributed to the funds gathered by the community to construct the building at Broad and Simmons Streets. Dedicated in 1902, the library had a large reading room on the second floor and a room for children on the first floor. The library also included a men's smoking lounge, and offices for the school board and the Grand Army of the Republic. An electrical short in an exhaust fan caused a heartbreaking fire on the evening of May 9, 1958. Low city water pressure complicated the firefighters' efforts. The building was gutted, and most of the collection was lost.

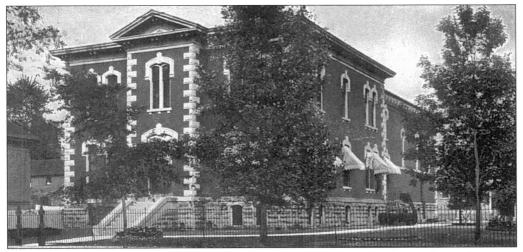

Knox County Jail. Erected in 1874 on land donated by the City of Galesburg, the Knox County Jail served the community for 102 years before being sold into private hands for a residence. William Quayle of Peoria was the architect who designed the building on South Cherry Street. Ten rooms at the front of the building made up the living quarters for the sheriff and his family. The cellblock at the back of the building consisted of 36 small cells in six rows, back-to-back; four larger cells on the second floor were for women. Acquired by Knox College in 1995, the old jail was adapted for use as offices and seminar rooms.

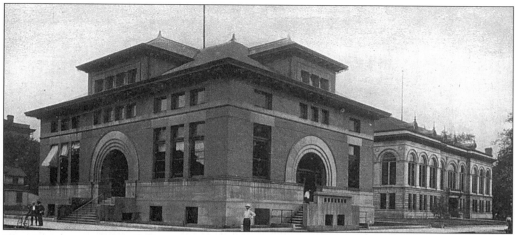

The Government Building. The first post offices in Galesburg were often located in the homes of the postmasters. In the 1850s, the post offices were housed in buildings downtown. Known at the turn of the century as the Government Building, the building pictured here was at the southeast corner of Cherry and Simmons Streets. It served as the post office and other government offices from 1894 until the 1930s. Designed by government architects, this was the second plan to be presented to Galesburg. The first plan was rejected in favor of a more ornate building. After the post office was built on Main Street, the most significant use of this building was as the Galesburg Youth Center until the late 1950s, when it was razed.

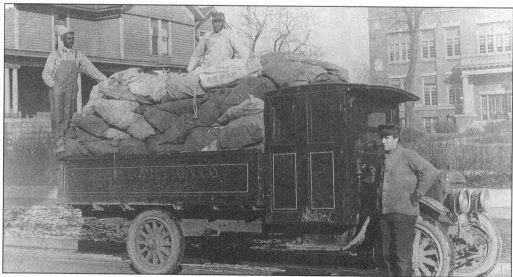

Mail for Delivery. Free mail delivery to homes did not begin in Galesburg until 1883, and it was the impetus to officially assign numbers to all the houses. In 1912, the U.S. Mail parcel post system was initiated, creating the opportunity to deliver packages and goods by mail. It was not unusual to send even chickens through the mail. Parcel post delivery opened the door for mail order businesses, which have become commonplace now. The truck here from O.T. Johnson Co.—"Retailers of Everything"—is parked in front of the Galesburg Club at Prairie and Ferris Streets.

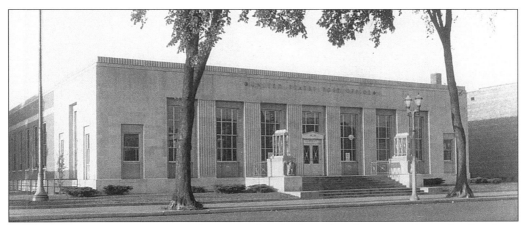

Post Office on Main Street. What some locals thought of as a product of a frivolous Democratic administration in Washington, the construction of a new post office building was completed in 1937. It is a building designed by local architect Harry G. Aldrich (1889–1973), with a distinctive Art Deco style. In Galesburg's centenary year, it was significant that the mural painted for the lobby by W.P.A. artist Aaron Bohrod celebrated Log City and our town founders. The mural can still be seen today in the post office lobby.

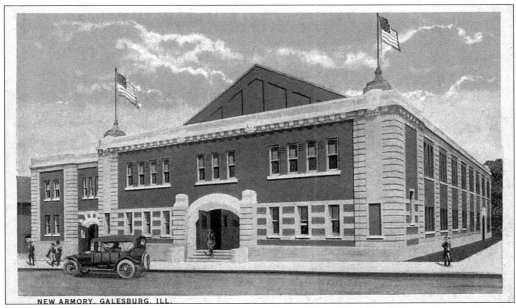

The Galesburg Armory. Battery C, 2nd Battalion, 123rd Field Artillery is housed at the Galesburg Armory, and the unit has roots from as far back as the Black Hawk War in 1832. The 123rd was called to WW I in 1918, and served in France until the end of the war. The armory was constructed in 1915 on North Broad Street and is the oldest armory in the State of Illinois still in use. The building was modified in 1929 to include a firing range in the basement. Over the years, the armory has been the site of countless community events for rallies, boxing matches, circus performances, balls, and banquets.

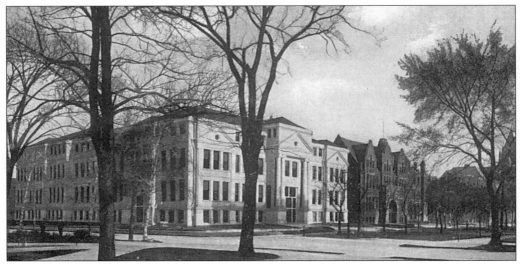

Galesburg High School. The building on the corner is Galesburg High School, built in 1904. The school was built after a disastrous fire destroyed the high school building that had been constructed on the same site in 1888. At the corner of South Broad and West Tompkins Streets, the building designed by J.Grant Beadle (1865–1929) was described as the finest in the state and a model of modern education principles. This high school building burned as well in September 1965, after it had been vacated. Classes had moved to the new building on West Fremont Street four years earlier. Next to GHS on the corner is the red brick Central Primary School. Central Congregational Church is at the far right of the card.

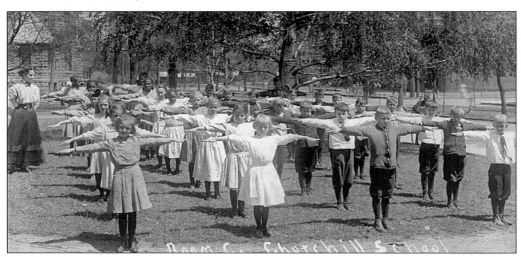

Physical Exercise at School. The free, graded school system was established in Galesburg in 1859. Academic excellence was strongly promoted by George Churchill (1829–1899), long-time principal of the Knox Academy, and the son of Galesburg founders. Built in 1867, Churchill School stood on Simmons Street across from Central Church. The last class attended in 1957. When it was razed, the new junior high school on Maple Street was named in George Churchill's honor. These students pictured above are exercising on the lawn to the east of Churchill School.

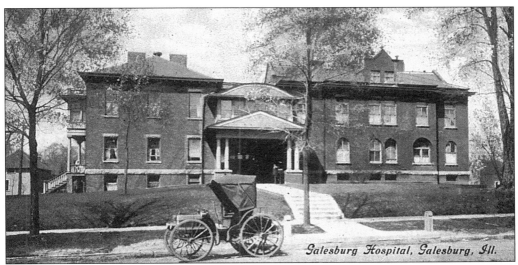

The Galesburg Hospital. As a result of a mass community meeting held in 1891, plans were made to establish the Galesburg Hospital. The Cottage Hospital building on Seminary Street was purchased in 1892 for $4,500 and contained 20 rooms, enough for 17 beds. It was opened on July 4, 1893, to "all classes of people," regardless of their ability to pay. The fee on the general medical ward was $1 a day. An additional wing was added in 1905, and another in 1910, which was described as "almost totally fireproof." A nurses' training school was organized in 1895. The north wing, the nurses' residence, was added in 1916 to accommodate the women—unmarried only, please!

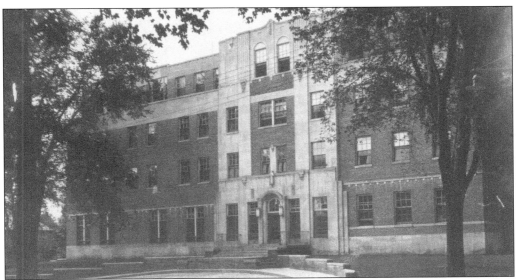

Galesburg Cottage Hospital. In 1931, great changes were made to modernize Galesburg Cottage Hospital, and a new building took the place of the old one. The north wing (1916) remained as the residence for the nurses until the "Nurses' Home" was built on the corner of Seminary and Losey Streets in 1945. Closed in 1972, the School of Nursing graduated 829 nurses. An additional wing was added in 1961, and another $9 million addition was constructed in 1973.

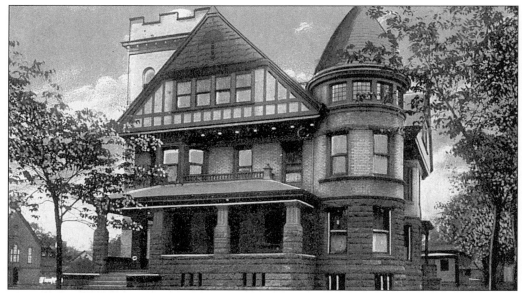

St. Mary's Hospital in the Beginning. St. Mary's Hospital was established in 1909 in the former residence of G.W. Thompson, Circuit and Appellate Court judge at 239 South Cherry Street. The home was remodeled to provide patient rooms, a surgical suite, a supply and scrub room, and a small chapel. The large Queen Anne-style house, across from the Knox County Courthouse, was designed by architect Norman K. Aldrich (1856–1933). After construction of the new hospital pictured below, the Thompson house was used as a convent. This modest beginning developed into a modern medical campus on North Seminary Street in the 1970s.

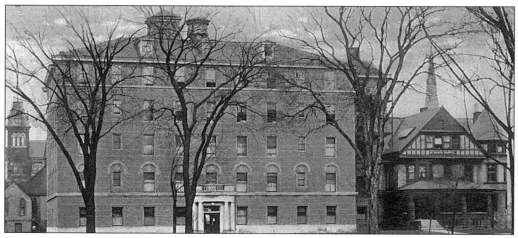

St. Mary's Hospital. In 1914, the founders of St. Mary's Hospital, Sisters of the Third Order of St. Francis (Peoria), constructed a five-story hospital on the corner of South Cherry and East Tompkins Streets. Another wing was constructed on the Tompkins Street side in the 1930s. An emergency and surgical services wing was added on the south side of the main building in 1961, and the Thompson house was razed. The tower of Corpus Christi High School is visible to the left behind the hospital, and the spire of Corpus Christi Church to the right behind the hospital's original structure.

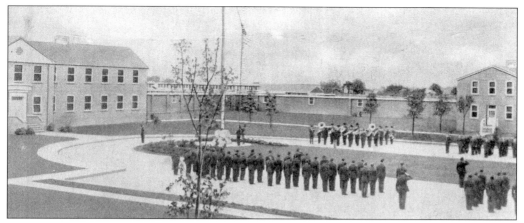

Mayo General Hospital. WW II veterans came home, but many wounded needed rehabilitation and continued medical attention. In July of 1944, the Mayo General Hospital was dedicated, but the first patients had arrived in April. The hospital, one of 60 such military hospitals in the country, boasted a staff of medical experts and "every known piece of medical equipment." Constructed on 115 acres on North Seminary Street, Mayo Hospital consisted of 94 inter-connected buildings. It was possible to walk throughout the hospital and remain indoors.

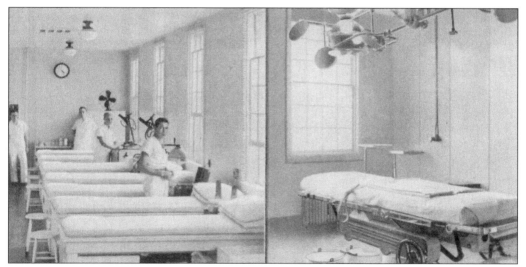

Mayo Hospital, View of the Wards. The complex included patient wards, laboratories, three mess halls, warehouses, a gymnasium, a recreation hall, a chapel, an auditorium, a post exchange, a Red Cross office, laundry, and a post office. There were quarters for officers, enlisted men, nurses, and WACS. In addition, one unit housed German prisoners of war. When the hospital was closed in 1946, the state established the University of Illinois Extension to accommodate the enormous numbers of veterans seeking academic degrees. Five years later, the University Extension was closed and reopened again as a hospital. After 36 years as the Illinois State Research Hospital, the property was deeded to the city. Many of the buildings that originally housed the Mayo General Hospital remain and have been purchased and adapted to new uses. The hospital site is a resourceful development known now as the Hawthorne Center.

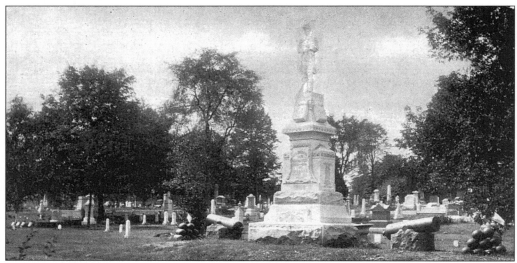

Civil War Monument. The monument to the Civil War soldiers in Hope Cemetery was designed of Barre granite and executed by local stone cutter, George Craig, at the request of the Women's Relief Corp, the auxiliary of the Grand Army of the Republic. The monument was dedicated in October 1896, by Robert Todd Lincoln, Abraham Lincoln's son, as part of the first Lincoln-Douglas Debate Celebration. Hope Cemetery was described in 1870 as "a beautiful retreat, well adapted as a sacred spot for the reception of the departed, where monuments to their memory are preserved and cherished as a solace to the living."

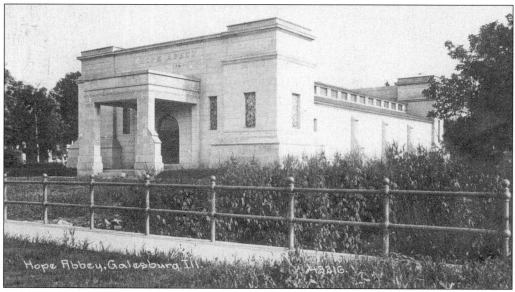

Hope Abbey. Hope Abbey was established independently of Hope Cemetery, and has been operated separately since the time it was dedicated in June of 1912. With reinforced concrete on the exterior, the interior of Hope Abbey is bright and white, with a marble ceiling, walls, and floor. There are nearly 500 crypts, and some of the community's most illustrious citizens are entombed here.

Three
This is the College City

On the Way to Knox College. "The Way to Knox" was a visual link between the community and the college around which the town grew. An avenue of stately elms began at the Public Square and ran along the South Broad Street boulevard in front of Central Congregational Church on the corner. The trees continued between the public library and Beecher Chapel on the east, and Central School and the high school buildings on the west. The Way then led across Standish Park and up to the doors of Old Main. The loss of the trees to disease in the 1960s is still felt by those who walk along that path.

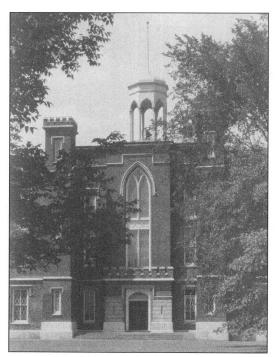

Old Main at Knox College. A national depression, a fire, and financial miscalculations prevented Knox College from constructing a significant building on the campus until 20 years after the arrival of the founders. In 1856, Charles Ulrichson from Peoria was selected as the architect to build the main college building. The brick structure, which came to be known as Old Main, was constructed in a style called Collegiate Gothic. The main building, with its bell tower rising 80 feet, must have been a commanding sight in a small prairie town where trees were few.

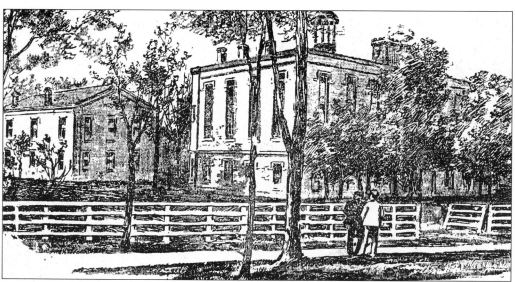

Old Main & East Bricks. This postcard is an artist's view of Old Main and East Bricks, built in 1845. The Bricks—East and West—were the first two college buildings actually constructed on the campus grounds. They served as meeting space and dormitories for men until they were removed before the turn of the century. Old Main was constructed in 1857 between the Bricks. Together the buildings gave the community the impression of stability, as well as a reminder of the goal of the college to bring education to the prairie. The Bricks eventually deteriorated, and West Bricks was taken down to enable the construction of Alumni Hall in 1890. East Bricks was the last to go, in about 1900.

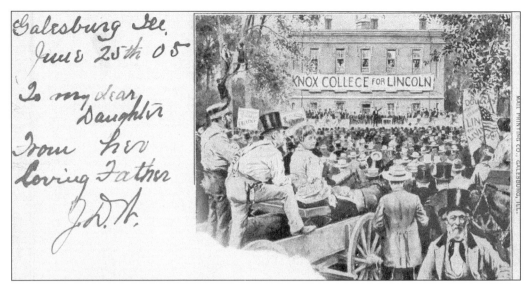

Lincoln-Douglas Debate. Construction of Old Main began in 1857, and was completed in time to shelter the fifth senatorial debate between Abraham Lincoln and Stephen A. Douglas in October of 1858. Victor Perrard's impression of how the debate must have looked was printed in 1896 in *McClure's Magazine* (published by Knox graduate S.S. McClure from 1857 to 1949) to announce the first of many celebrations of the debate. The candidates debated on the east side of the building, and thousands crowded into town to hear them speak.

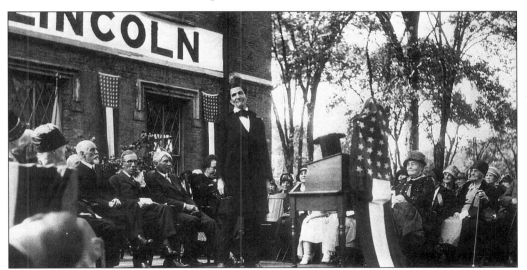

Debate Anniversary in 1928. Knox College and the City of Galesburg celebrated the 70th anniversary of the Lincoln-Douglas Debate in 1928. The event included a debate re-enactment on the east side of Old Main. In this postcard, the dignitaries on the platform include Galesburg's favorite poet, Carl Sandburg (1878–1967). Sandburg, third man from left, attended Knox's cross-town rival Lombard College, but in later years became a friend of Knox. He spoke at Old Main in 1937, and again at the Debate Centennial in 1958.

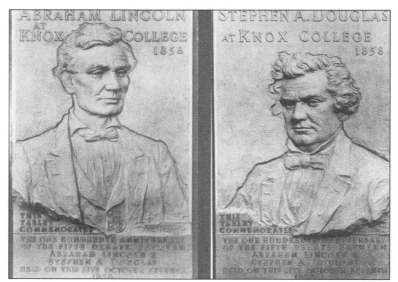

Abraham Lincoln and Stephen A. Douglas. At the debate in Galesburg, Abraham Lincoln took a bold stance against slavery, saying "He is blowing out the moral lights around us who contends that whoever wants slaves has a right to hold them." Today on the east side of Knox's Old Main, two plaques by sculptor Avard Fairbanks commemorate the debate between Lincoln and Stephen Douglas. Named to the National Register of Historic Sites in 1936, Old Main is the only remaining building associated with those famous debates.

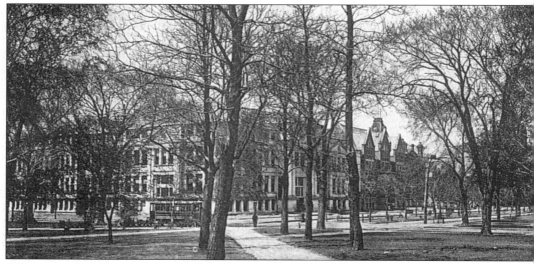

A Panoramic View. Whiting Hall (right), and the Galesburg High School (left), helped to frame Standish Park on the north side, with Knox College on the south. Other public school buildings north of the high school faced Beecher Chapel and the public library across South Broad Street, hidden in this view by Whiting Hall. The town clearly had pride in what these buildings represented. The symbols of the progress of education, spiritual influences, and community were all apparent in these few blocks. Together these institutions created a kind of open educational campus that must have reflected

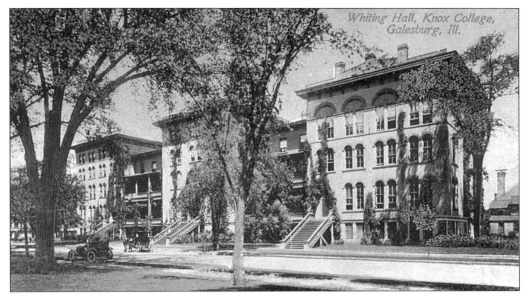

Whiting Hall. The Knox Female Seminary, constructed in 1857, was home to the women of Knox College for nearly 120 years. Additions were made to the east in 1885, and to the west in 1892. After 1887, the east wing was the first home of the Knox Conservatory of Music. The building was named Whiting Hall, in honor of Maria Whiting, long-time principal of the seminary, and Knox College benefactor. Women students lived in Whiting Hall until 1979, when it was closed.

the town's positive values and expectations for the future. The concentration of Lombard College, Brown's Business College, and Knox in the same town helped to win for Galesburg the nickname of the "College City." It was a turn-of-the-century name that many businesses sought to cash in on, from the College City Laundry to the College City Electric Company. Even the Turley Candy Company claimed to offer "candy with a college education."

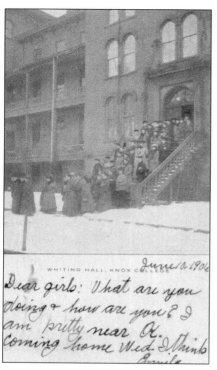

On the Way to Class. Education for women was important to the Knox College founders, and the first academic building constructed on the prairie was to be a seminary women. However, the course of study for women differed from that of the male students. In fact, graduation requirements for women were more stringent. It was not until early in the 1870s that women were allowed to graduate from the college with the same degree as men. Although course of study for women required six years, men routinely graduated in four.

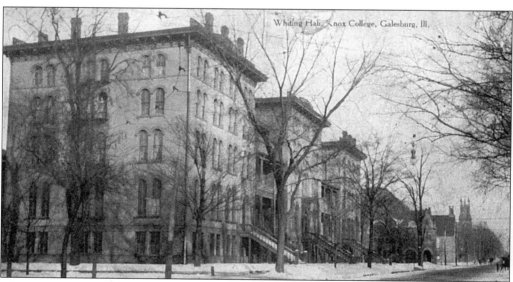

A View of Whiting Hall. During the 1880s, the female seminary was a self-contained educational institution, complete with parlors, chapel, library, dining rooms, and a bowling alley. In the 1980s, Whiting Hall was transferred to a developer who made extensive modifications and converted the structure to elder housing. It remains a vital building, and an essential architectural anchor to the historical heart of Galesburg. The First Baptist Church, the African Methodist-Episcopal (AME) Church, and the Methodist Episcopal Church are located on the right of this card.

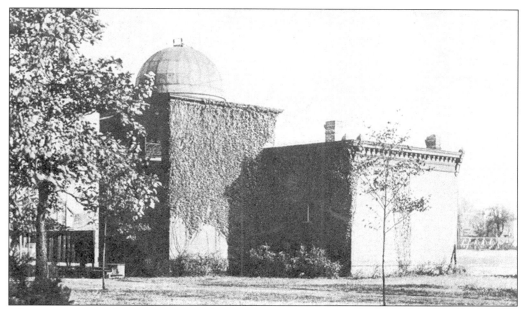

Observatory. Built in 1899, complete with movable dome and two rooms on the main floor, the Observatory was the particular domain of Professor Edgar Larkin and his telescope. Larkin was immortalized when Knox College alumnus Edgar Lee Masters (1869–1950), Knox Academy Class of 1890, described him in *Spoon River Anthology* as "Professor Moon." Use of the Observatory was discontinued when the surrounding lights became too bright to view the stars. The little building was razed in 1964.

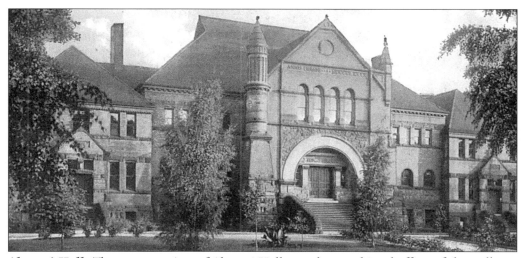

Alumni Hall. The construction of Alumni Hall was the combined effort of the college, the alumni, and two college literary societies. President Benjamin Harrison laid the cornerstone in 1890. The remarkable building has, over the years, housed the college theatre, library, recitation halls, language labs, chapel, classrooms, faculty and administrative offices, snack bar, indoor track, and a firing range. The architect was the flamboyant E.E. Meyers (1832–1909), designer of courthouses in Knox County and others in Illinois, and several state capitols.

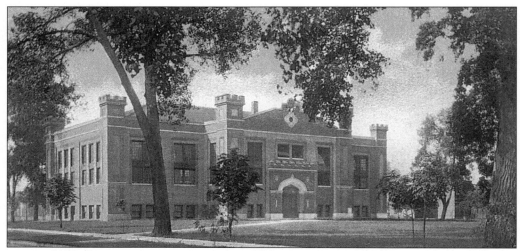

Gymnasium. As the last century turned, athletic events were beginning to generate the kind of excitement and collegiate pride that oratory and literary societies had decades before. In 1908, Knox College followed a plan developed by J. Grant Beadle (1865–1929) and constructed a gymnasium that replaced one built by the students themselves. After construction of the new gym in 1951, this building was used more often for women's athletic events. Today the building remains in use and is an integral part of the college's plan for the future.

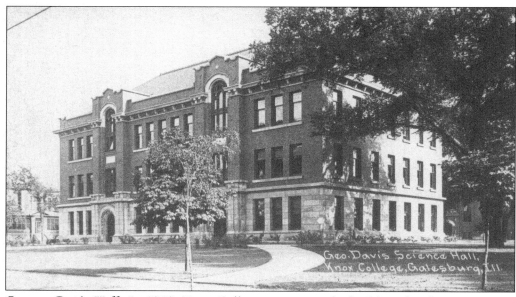

George Davis Hall. In 1912, Knox College constructed a building for the sciences on the northeast corner of the campus at East South and South Cherry Streets. The first floor was designated for physics, the second for biology, and the third for chemistry. A museum and vivarium were located on the fourth floor. George Davis Hall was named for long-time treasurer of the college. It remained the seat of the sciences on campus until the construction of the Umbeck Center on South West Street in 1972. Presently, Davis Hall houses classrooms and faculty offices.

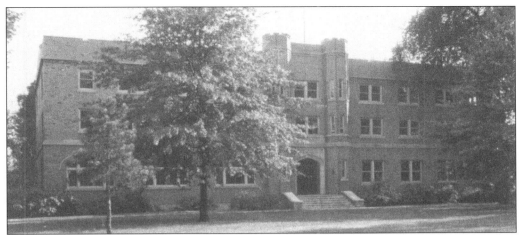

Seymour Hall. Lyman K. Seymour (1865–1942), Knox Class of 1886, gave the hall which bears his name to the college in 1920. Since the demolition of West Bricks in 1900, there had been no accommodations for men on campus. The hall was designed by Norman K. Aldrich (1856–1933) with social rooms on the first floor, a suite for the housemother, and a dining hall in the south wing. Rooms for men were on the floors above. Various modifications have updated Seymour Hall over the years, including the addition of a new dining hall wing in 1960, meeting rooms, administrative offices, and a gathering place affectionately called The Gizmo.

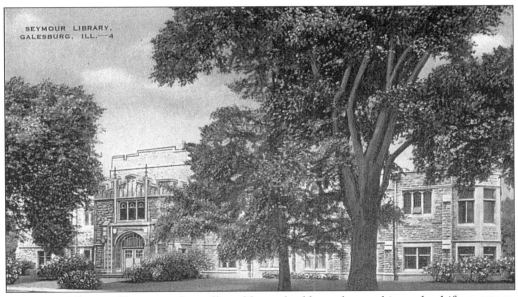

Seymour Library. For years the college library had been housed in makeshift quarters, first in Old Main and then in Alumni Hall. In 1928, Henry M. Seymour, Knox Class of 1884, and brother to Lyman, gave the college a library building which was designed by Chicago architects Coolidge and Hodgdon. Made of limestone quarried in Payson, Illinois, Seymour Library is a style known as Tudor Gothic. The library collections were consolidated in elegant surroundings, and the building itself remains at the heart of the campus.

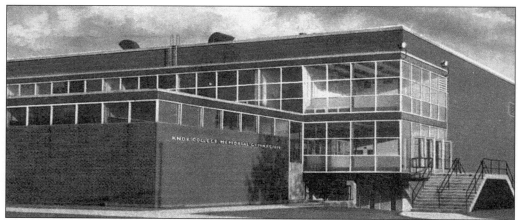

Memorial Gym. The business community of Galesburg and Knox College came together to fund a gymnasium that would stand as a significant memorial to the men who served in World War II. The idea originated in 1944, but the ground-breaking did not occur until six years later. The dedication of Memorial Gymnasium was celebrated in 1951, and since then the building has hosted athletic competitions, commencements, dances, and feasts. Because of its seating capacity of nearly 4,000, the gym has also been utilized for countless community-wide events and performances.

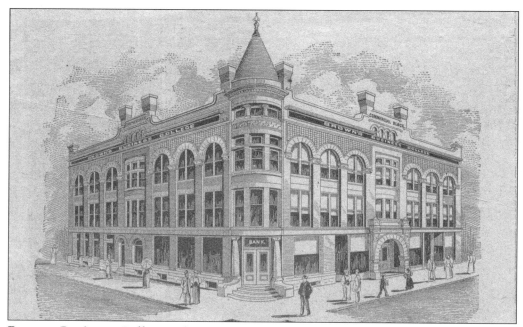

Browns Business College. The Western Business Institute became Brown's Business College in the 1890s. George W. Brown—not the local inventor of the cornplanter—operated a chain of over 20 such schools in Indiana, Illinois, and Iowa. Brown's Business College occupied the upper floor in the building at Cherry and Simmons Streets. The school was a fixture in Galesburg until 1967, teaching office skills, sign lettering, bookkeeping, and advertising. It was the college designed to complete "Galesburg's educational ladder."

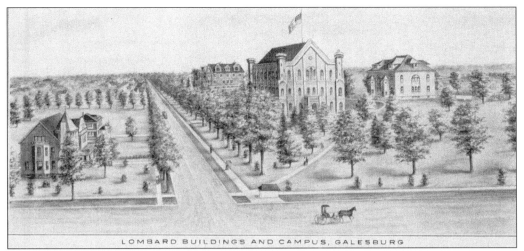

Lombard College Campus. A devastating fire in 1855 stalled the development of the Illinois Liberal Institute, established by the Universalist Church just two years before. With a significant financial gift, the school recovered and became Lombard College. This 1915 campus view, looking east at the corner of East Knox and Lombard Streets (where Lombard Junior High School is today), shows faculty residences to the left. Old Main and Lombard Hall, a dormitory for women, face Knox Street. The gymnasium is to the right.

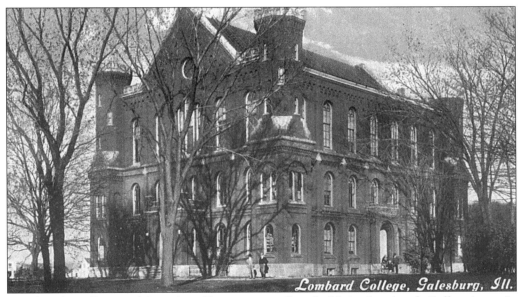

Lombard College Old Main. Classes were first held in Lombard College's main building in 1856, and it remained the central college structure, housing classrooms, offices, a library, and a chapel. It was here that Carl Sandburg (1878–1967), as a student in 1899, rang the bell to call students to class. The building was designed by W.W. Boyington, a Chicago architect with a national reputation. Mr. Boyington designed churches, collegiate buildings, and the famous Chicago Water Tower. Old Main was razed in July 1955.

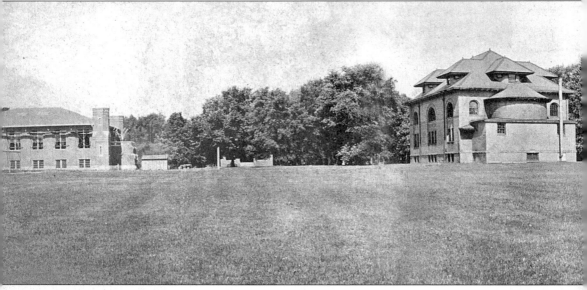

Lombard College Campus. This view from the south playing fields of the Lombard Campus shows the gymnasium on the left, Tompkins Hall, Old Main (nearly hidden in the trees), and Lombard Hall. One fraternity and two sorority bungalows (partially obscured by the trees to the far right) were constructed in a row on the east side of the campus. They remain in use today by Lombard Junior High School. The most significant element of the 14-acre campus, however, was the park-like grounds. An

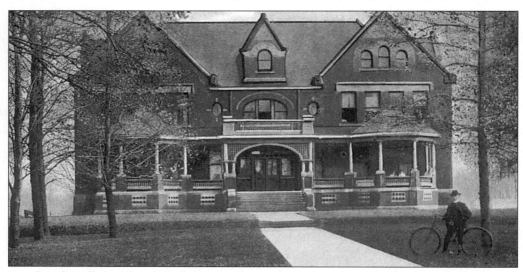

Lombard Hall. Lombard Hall, the residence for women, was built in 1896. Women at Lombard College were admitted on an equal basis with men from the beginning of the school. This attitude was a reflection of the philosophy of the Universalist Church of Illinois, the primary supporter of the school. So important was Lombard College in the scope of the church, that it became the seat of the Universalist Divinity School in the 1880s, and remained so until 1913, when it was transferred to the University of Chicago.

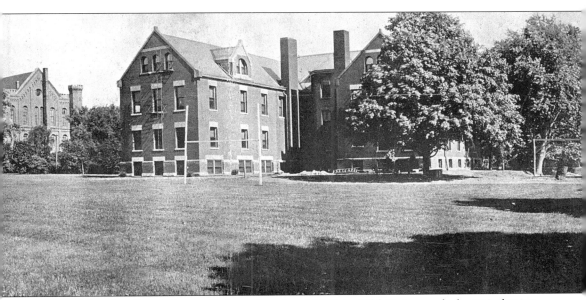

avenue of birches lined the walk from Lombard Hall to Old Main, and alumni classes regularly gave trees to enhance the campus. Guided by John Van Ness Standish (1825–1919), long-time faculty member and Lombard president, trees were planted according to a plan that provided shaded walks and spectacular specimens.

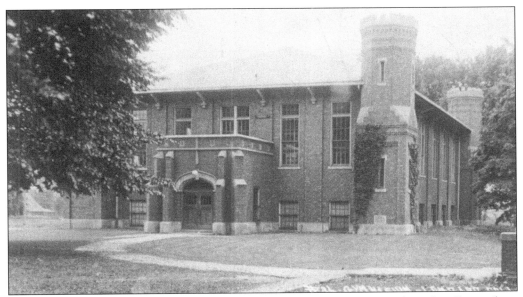

Gymnasium. The gymnasium, built in 1912, was constructed with all modern apparatus, including a raised running track. It was the last new building added to the Lombard College campus and is among the final remnants of the college. Today it is used by Lombard Junior High School students. The Great Depression hit Lombard College and her students hard. The last class graduated in 1930. The college did not merge with Knox, but many students chose to finish their degrees there, and Knox welcomed them. Knox has since been the center of Lombard College alumni activities.

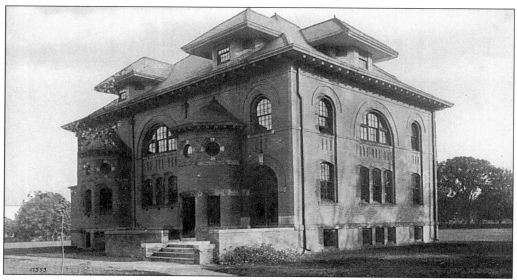

Tompkins Science Hall. The building pictured here was built in 1897 and was the original gymnasium, combined with the Department of Expression and English with space for oratory and theatrical performances. After the construction of the new gym, it was remodeled and called Alumni Hall. Finally the building was reworked and rededicated in 1922 as Tompkins Science Hall. Tompkins Hall was razed in the summer of 1990.

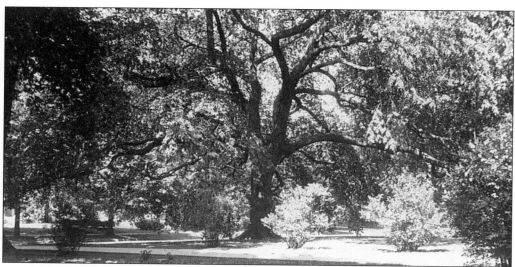

Lombard Elm. Even on the tree-crowded campus, the Lombard elm was remarkable. It gained national significance in the 1930s and 1940s as the largest elm in the United States, with a spread of over 140 feet. It was even recognized by *Ripley's Believe It or Not*. By the time it was taken down in 1966, its branches were held together by 400 feet of cable. Nearly one hundred years old when it was lost to disease, the elm was planted in 1868 as a memorial to those Lombard students who had fought in the Civil War.

Four
TAKING CARE OF BUSINESS

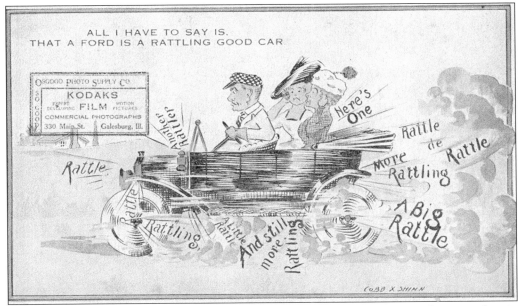

Osgood Photo Service. Charles Osgood (1863–1951) learned from a photographer in New Windsor how easy it was to make tintypes. He then set up shop in Wataga, and later in Victoria, Illinois. He soon came to Galesburg, and his shop at 330 East Main Street was the perfect location to see what was happening in the 'Burg. Later he moved his shop to Seminary Street, but for nearly 70 years he and his camera captured private and public events throughout the area. Today we all owe a great debt to him for the history his work recorded. This advertising postcard declares that Osgood Photo Supply is "O So Good."

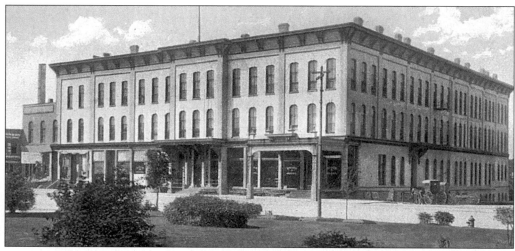

Union Hotel. Built first in 1869, the Union Hotel was at the heart of the city, on the Public Square. It burned to the ground in 1871, but was rebuilt immediately. The hotel was remodeled in 1890 and proudly advertised that there was "hot and cold running water to each room." The Union Hotel became the Broadview Hotel in the early 1920s. It stood on the northwest corner of Broad and Main Streets, where there is a hotel today.

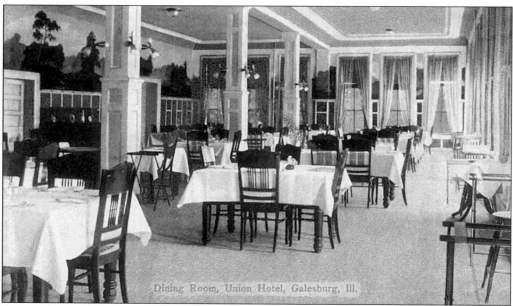

Union Hotel Interior. This postcard shows the interior of the Union Hotel around the turn of the last century, before it became the Broadview Hotel in the early 1920s. In June of 1969, the Broadview Hotel burned under suspicious circumstances. Fire crews from four neighboring towns assisted in striking out the blaze. The most intense pocket of fire reportedly was in the area of the fabled Steeplechase Room. The hotel had been vacated earlier in the year and was scheduled for demolition as part of Galesburg's Urban Renewal Project for the Public Square.

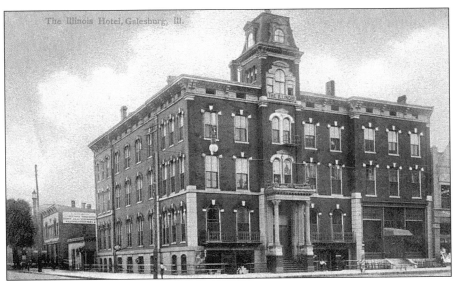

Illinois Hotel. When this hotel was built at the corner of Kellogg and Main Streets in 1872, it was called Brown's Hotel. The owner was George W. Brown (1815–1895), a Galesburg man famous for the invention and manufacture of the cornplanter. The building was remodeled and renamed the Illinois Hotel in 1903, but it didn't last. The corner was cleared in 1915 to construct the Hill Arcade, designed by J. Grant Beadle (1865–1929), and built by Henry C. Hill (1876–1956). Hill later became a prison warden, gaining a national reputation as a reformer. The Illinois state prison facility here is named for him.

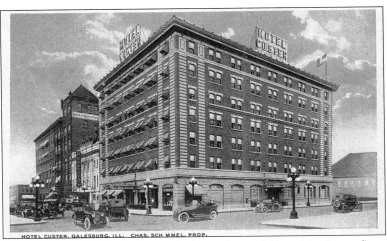

Hotel Custer. The Hotel Custer was dedicated in 1915, with three floors and one hundred rooms. Built by Charles Schimmel (1872–1938), and named for Omer N. Custer (1873–1942), the hotel was so successful that two more floors were added in 1917. In 1939, another major addition was made to the east, adding more rooms and banquet space. Thirty years later it was sold by the Schimmel family, and in the 1960s and 1970s, the Custer Hotel suffered serious financial difficulties. Finally the building was successfully converted to a residential hotel for the elderly, known now as the Kensington. To the left are the Orpheum Theatre and the Bank of Galesburg building.

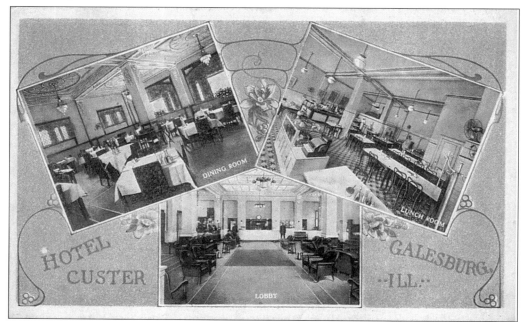

Hotel Custer Interior. This postcard depicts the interior of the Hotel Custer. A self-made man, O.N. Custer (1873–1942) was active in newspaper publishing, banking, farming, and politics, as well as various manufacturing enterprises. He was the Galesburg postmaster (1908–1913) and twice the Illinois State Treasurer (1925–1927 and 1929–1931), but was defeated in a run for Illinois governor in 1932. O.N. Custer made connections and developed a sphere of influence and power. He was a tireless promoter for the town, working to bring business and recognition to Galesburg.

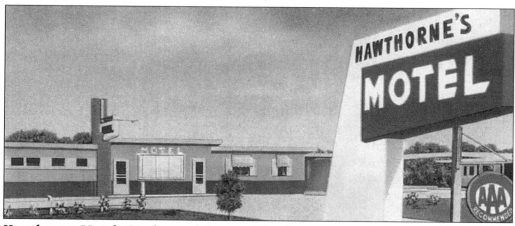

Hawthorne Motel. Stanley and Stewart Hawthorne opened the Hawthorne Motel along U.S. Highway 150, situated in what was a high traffic area across from the road to Lake Storey. In 1951, it was a prime location for the 24-unit motel. Its AAA rating, televisions, and air-conditioned rooms were proudly promoted. The motel was sold in 1967, and it has recently fallen on hard times. The message on this postcard reads: "Today we are the people who stay off the highway and watch the others hurry to places."

Auditorium. The Auditorium was built in 1890, and had the enormous seating capacity of 1,300. William Wolf (1838–1906) was the architect who designed the building, which still stands on North Broad Street at Ferris Street. In 1907, the Auditorium was modified for electric lights, new carpet, and seating. A newspaper of the day revealed, "Upholstered seats are no more in theatres as the managers say that dead head germs are so easily collected in them." Furthermore, the stage rules were as follows: "No smoking, tobacco, or rag chewing, profanity, insolence, or drinking allowed on stage." When the Auditorium closed, the structure became the Galesburg Glass Company at 85 North Broad Street.

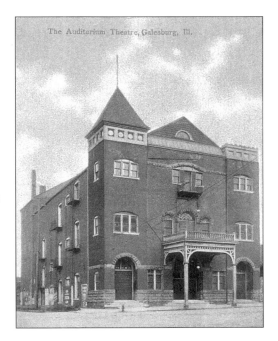

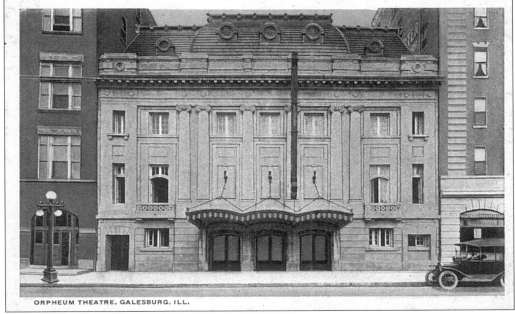

Orpheum Theatre. Elegant from the day it was designed by architects George and C.W. Rapp, the Orpheum Theatre at 57 South Kellogg Street was salvaged from oblivion by the community's hard work and determination. Built in 1916 as a vaudeville theatre able to hold more than a thousand, the Orpheum was later used as a movie house. By the 1980s, the Orpheum had fallen into disrepair and closed. In 1988, after a $2 million renovation, the Orpheum opened its doors to live theater and music again, as a true community endeavor.

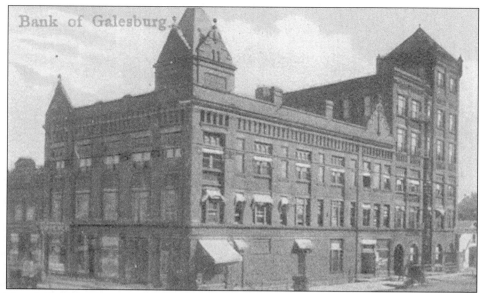

Bank of Galesburg. Known eventually as the Bank of Galesburg, the building at the southwest corner of Main and Kellogg Streets was constructed in 1886 as the Fraternity Building. Designed by local architect William Wolf (1838–1906), the building provided meeting space for the Odd Fellows and offices for the Covenant Mutual Benefit Association, a highly successful insurance firm. Over the years, the structure provided office space for generations of businesses and professionals. Sadly, it did not survive, and was razed in 1992.

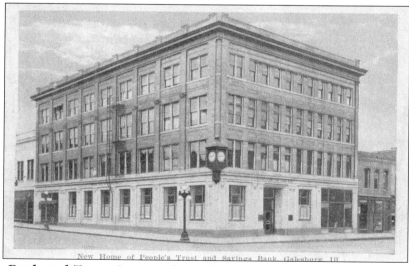

People's Bank and Trust. Organized in 1900, the People's Bank and Trust Company established offices on the northwest corner of Main and Prairie Streets. The bank purchased the Holmes Building at the southwest corner of Prairie and Main Streets in 1921, and constructed the fine new building on this card in 1925. Five years later, the People's Bank merged with the First National Bank. Even during the hard times of the Great Depression, Galesburg never suffered a bank failure.

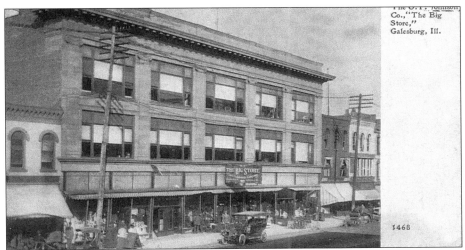

O.T. Johnson's. O.T. Johnson's Department Store grew from a small dry goods store, opened in 1864 by O.T. Johnson and Robert Chappell, to 3.5 acres of floor space. It became truly "The Big Store." The main building, built in 1904, faced Main Street at 125 East Main. The five-story annex added in 1910, connected by an enclosed bridge, was located behind, at 152 East Ferris Street. Ads early in the century described the store as the largest retail store outside of Chicago. Stock and size gradually diminished until the store finally closed in 1977.

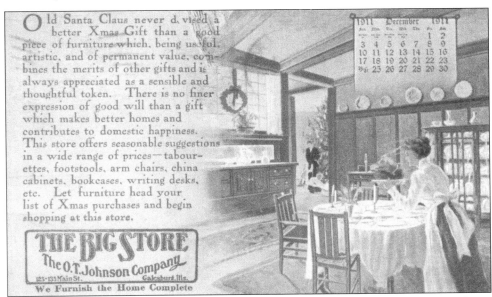

The Big Store. The O.T. Johnson Company described itself as "family outfitters," providing "everything to wear and everything for the home." It was a claim the Big Store could easily make. In 1904, the store was rebuilt to accommodate 34 departments. In addition to clothing departments, there were hardware and paint, books and stationery, furniture and china, rugs and draperies, and lighting fixtures and art glass. There was a hair salon and a flower shop, as well as a bakery and a soda fountain. A 1912 ad announced free concerts daily in the Phonograph Shop.

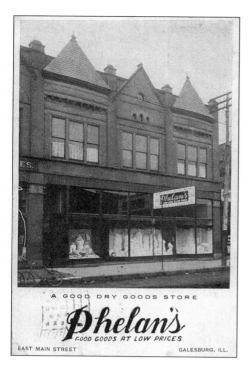

Phelan's Dry Goods Store. This architectural classic remains in use on the south side of Main Street, between Kellogg and Prairie Streets, at 232–234 East Main Street. Phelan's Dry Goods sent out this advertising postcard in 1907, promoting "good goods at low prices." Phelan's sold men's and women's "furnishings"—that is, shirts, hats, ties, and gloves. It was the sort of place where one could buy a fine union suit—with pearl buttons—for 50¢.

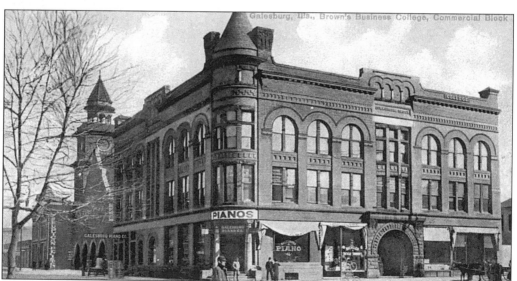

The Commercial Block. The building that housed Brown's Business College was known as the Commercial Block. Built by Galesburg architect William Wolf, it still stands at the southeast corner of Cherry and Simmons Streets. At the time of this postcard (1909), the Galesburg Piano Company, which sold Lombard Pianos, occupied the first floor. Visible to the east down Simmons Street is the Central Fire Station, with its bell tower still intact. The offices of the *Republican-Register*, the ancestor of the *Galesburg Register-Mail,* can be seen as well.

Churchill Hardware Store. Churchill Hardware was operated by G.B. Churchill (1865–1931), the son of the local educator, George Churchill. G.B. Churchill opened this store at 39 North Prairie Street when he was 17. He initiated a kind of self-serve concept to his customers, which was quite remarkable at the time. He was commended in several national magazines for his enterprise and advertising initiative, which was reflected in the motto of the store. A large owl was featured in ads and at the store, accompanied by the phrase: "We Never Sleep." Later Churchill moved to a larger Main Street location, the building that later became Kellogg and Drake Department Store at 246 East Main Street.

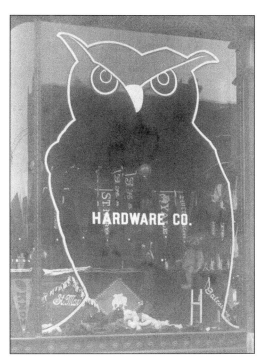

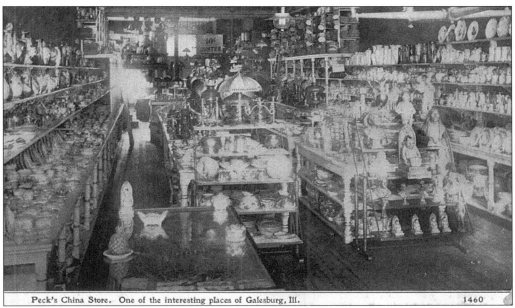

Peck's China Store. This view of Peck's China Store at 220 East Main Street shows what they advertised as the "largest stock in the city of China, Glass, etc." Syracuse, Grindley's English, and Warwick and Haviland dinner sets were advertised for $20. George F. Peck even produced postcards of local views. This one states that Peck's China Store is "one of the interesting places in Galesburg." In business for 25 years, the store was a familiar site on the south side of Main, between Prairie and Kellogg Streets.

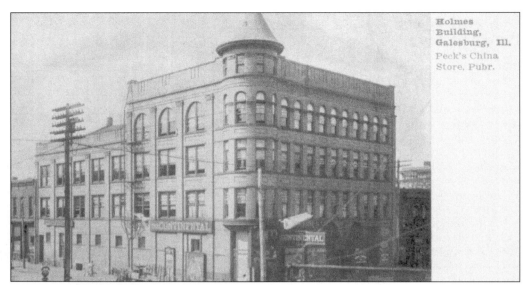

Holmes Building. The Galesburg Opera House at the southwest corner of Main and Prairie Streets was remodeled in 1899, and became known as the Holmes Building. It had 80 commodious offices and a first-class elevator. The Continental Clothing Company was located on the first floor. The building was listed among the accomplishments of William Wolf (1838–1906), the architect for many of the residential and commercial buildings in Galesburg. Born in Philadelphia, Wolf moved to Kewanee in 1865. There he worked as an architect and builder, moving to Galesburg in 1887. Mr. Wolf is in many ways responsible for the prosperous look of Galesburg at the turn of the century.

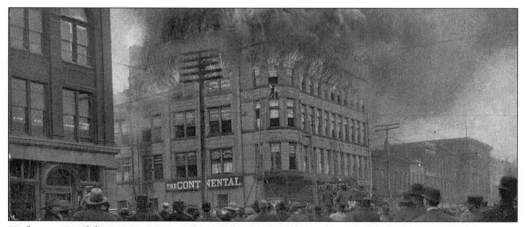

Holmes Building on Fire. The Holmes Building fire started about 3:00 p.m. on December 15, 1908. It spread so quickly that when the fire department arrived, several people on the fourth floor were desperate to escape. Dr. E.D. Wing actually hung from the sill holding his overcoat, as this card shows, until the ladder was in place to rescue him. There were no lives lost, but material damages amounted to $140,000. The largest loss was stock in the Continental Clothing Company. The building across Prairie Street on this postcard was the Galesburg National Bank, which later became the First Galesburg National Bank and Trust through a series of mergers.

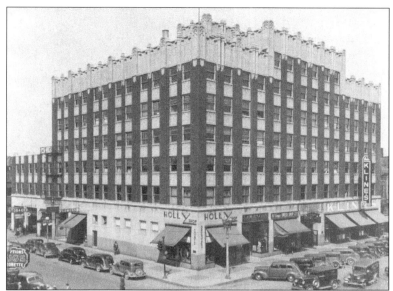

Bondi Building. Isidor Bondi (1868–1941) and Hart Bondi (1873–1934) came to Galesburg in 1897 to open a women's clothing store. The Bondi Bros. and Company flourished for many years on the southeast corner of Main and Cherry Streets. In the late 1920s, the Bondi brothers sold their store to Kline's, and then undertook the construction of the Bondi Building (designed by Indianapolis architect George Schreiber), which opened in 1929. Impressive in its size and Art Deco styling, the six-story office building remains today an icon of business enterprise in downtown Galesburg.

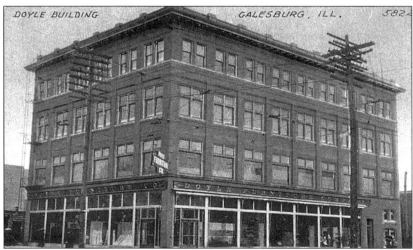

Doyles Furniture Store. W.E. Doyle (1869–1933) was in the furniture business (as well as carpets, stoves, and tin) at Prairie and Simmons Streets for nearly a decade. About 1910 he built the immense building at Main and Seminary Streets. It was a family business enterprise that lasted into the 1940s. The building remains to this day, having been used in the 1950s and 1960s by the department store Block and Kuhl, and currently serves as an appliance store.

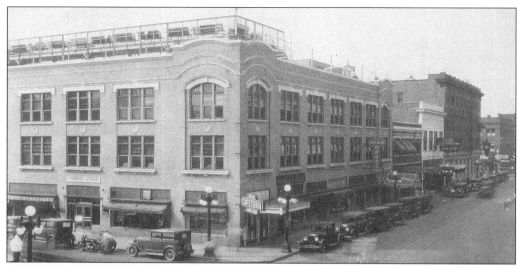

Weinberg Arcade. In the early 1920s, J. Grant Beadle (1865–1929), Galesburg architect, designed the Weinberg Arcade for brothers A.L. (1863–1940) and Lafayette (1868–1928) Weinberg, who had been in the wholesale fruit and produce business since 1891. The Weinberg Building still stands at the northeast corner of Prairie and Simmons Streets. Originally with only three floors, the office building was built with an arcade on the first floor with shops opening to an interior hallway, as well as to the street.

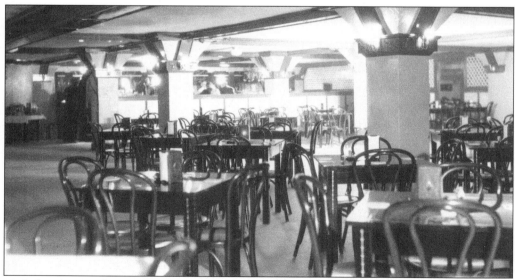

Weinberg Arcade—To Serve You. Some of the shops at the Weinberg Arcade—the Illinois Camera Shop, Treasure Trove, the Whitcraft Shop, and the Ida Ann Shoppe for women's clothing, among others—were in business for decades at the same address. Restaurants in the Weinberg served generations of diners—the Arcade Cafeteria and Lunch Room (1920s), the Club Arcade, pictured here in the 1930s, Bobbitt's Cafe (1930s), followed by the Coffee Corner (1940s), and much later, Infinity Plus One (1970s).

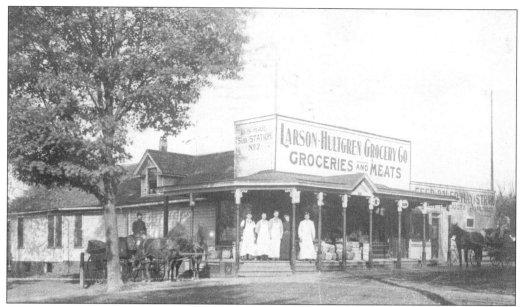

Larson & Hultgren Grocery. In 1909, Fred Larson and Fred Hultgren were operating a grocery at 808 South Cedar Street, which had the additional distinction of being a postal substation. In addition, one could stock up on hay and straw, not unlike the corner stores where today we can gas up and grab a gallon of milk. A grocery was operating at this site into the 1960s, although by 1928, F.O. Hultgren had moved his grocery to 1006 East Brooks Street, at Brooks and Pine Streets.

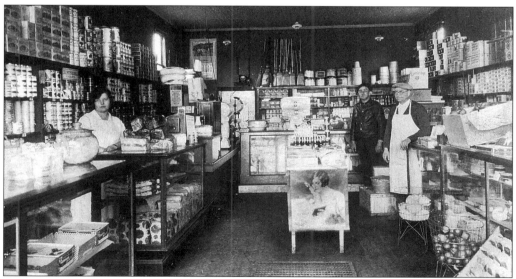

Swanson Grocery. Small groceries were a familiar and necessary element of each neighborhood. In the early 1920s, there were 119 such stores throughout Galesburg. In 1950, there were just over 80. Emil Swanson, far right, is pictured here in his grocery at 1212 East South Street, with Blanche Olson and E.C. Blockinlinger. There was a Swanson grocery at this address for over 50 years.

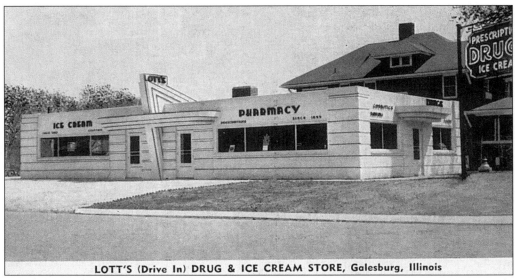

LOTT'S (Drive In) DRUG & ICE CREAM STORE, Galesburg, Illinois

Lott's Drug. Lott's Drug and Confectionery opened around 1940, built with a very trendy Art Deco style. Approximately 15 years later it became Tennyson's Drug Store, which, of course, was equipped with a soda fountain as any successful drug store would be. In 1960, the building was transformed into Elmer's Spudnut Shop. Today the donut shop at Broad and Fremont Streets, Swedough's, is crowded on Sunday mornings with the donut and coffee crowd.

DEAR SIRS:—
"In reply to your request to send a check I wish to inform you that the present condition of my bank account makes it almost impossible. My shattered financial condition is due to federal laws, state laws, county laws, city laws, corporation laws, liquor laws, mother-in-laws, brother-in-laws, sister-in-laws and out laws. Through these laws I am compelled to pay a business tax, amusement tax, head tax, school tax, gas tax, light tax, sales tax, liquor tax, carpet tax, income tax, food tax, furniture tax and excise tax. Even my brains are taxed I am required to get a business license, car license, hunting & fishing license, not to mention a marriage license and dog license. I am also required to contribute to every society and organization which the genius of man is capable of bringing to life; to women's relief, the unemployed relief and gold digger's relief. Also to every hospital and charitable institution in the city, including the Red Cross, clack cross, purple cross and double cross. For my own safety I am required to carry life insurance, property, liability, burglar, earthquake, business, accident, tornado, unemployment, old age and fire insurance. My business is so governed that it is no easy matter for me to find out who owns it. I am inspected, expected, suspected, disrespected, rejected, dejected, examined, reexamined, informed, required, summoned, fined, commanded and compelled until I provide an inexhaustible supply of money for every known need of the human race. Simply because I refuse to donate to something or other, I am boycotted, talked about, lied about, held up, held down and robbed until I am almost ruined—I can tell you honestly that except for the miracle that happened I could not enclose this check. The wolf that comes to many doors nowadays just had pups in my kitchen. I sold them and here is the money.
LOUIE'S LIQUOR STORE
Phone 3577 Main 251 E. Main St.
 GALESBURG, ILLINOIS

Louie's Liquor. Humor can be a persuasive advertising tool. This postcard mailed from Louie's Liquors was sent with a smile. Louis Zeldes began business in a tailoring shop in Galesburg, and later operated a liquor store. For 30 years Louie's Liquors was a familiar Galesburg business. When this card was mailed to customers in about 1944, Louie's Liquors was at 251 East Main Street. Later, his store moved to 41 South Seminary Street, where it finally closed in the mid-1970s.

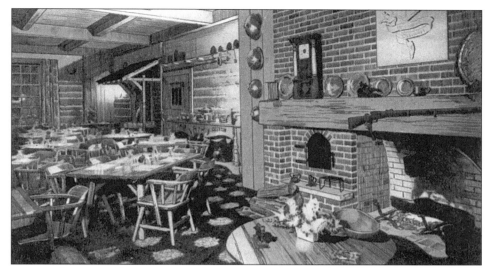

Homestead Room. The Homestead Room was the restaurant at the Hotel Custer, and was the premiere dining establishment in Galesburg for many years. Charles Schimmel (1872–1939), with the encouragement of O.N. Custer, built the hotel into a legendary Galesburg asset. Schimmel's four sons, who were raised in the hotel, went on to careers in hotel work, creating a chain of Schimmel hotels across the Midwest in Wichita, Omaha, and Kansas City. Charles Schimmel's son, Bernard (1909–1977), took over the operation of the Hotel Custer in 1936, after training as an hotelier in Switzerland.

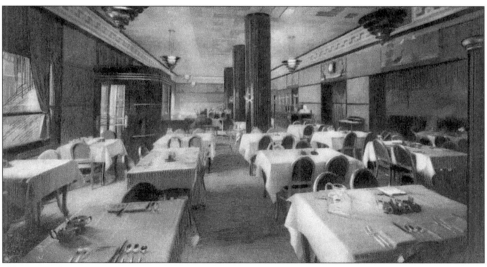

Coffee Grill. Bernard Schimmel oversaw the 1939 renovation of the hotel that added a six-story wing, including new restaurants, banquet rooms, and ballrooms. He established a reputation of elegance and service for the hotel. Famous for promoting the Rueben sandwich and Chatham Artillery Punch, Bernard Schimmel saw to it that unleavened bread was always served along with the rolls in the hotel restaurants. Mr. Schimmel, who had been a founding member of the Jewish temple here, Temple Sholom, left Galesburg in 1961 to assume the management of the Blackstone Hotel in Omaha. Many people in Galesburg thought it was the end of an era.

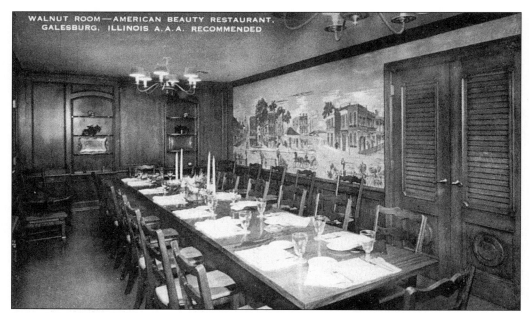

American Beauty. The American Beauty Restaurant at 308 East Main Street, famous for homemade candy and chicken croquettes, was a favorite spot. Established by Nicholas Cottos and Paul Poulos in the early 1920s, it occupied a prime downtown location next to the Bank of Galesburg. The Poulos family operated the restaurant from 1930 until it closed in 1969. Behind the restaurant, with its booths and white tiled floor, was the banquet room pictured on this postcard.

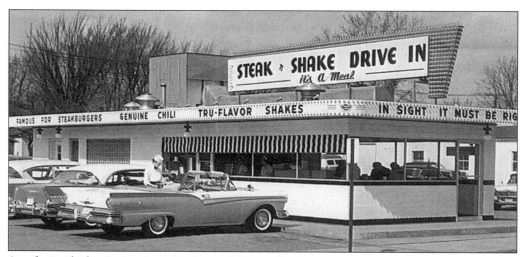

Steak & Shake Drive-in. The first address of Galesburg's Steak and Shake was at the corner of East Main and Fulton Streets, where uniformed carhops would bring orders to patrons waiting in their cars. It was, for nearly 30 years, one end of what was known as the "Strip." It was a convenient place for drivers who wanted to turn around and drive yet again down Main Street. Traffic gradually moved away from Main Street, however, and Steak and Shake built a second restaurant on Henderson Street. In the late 1970s, the Main Street Steak and Shake closed.

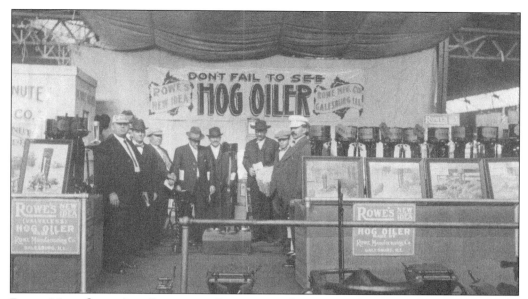

Rowe Manufacturing Company. Rowe Manufacturing was among Galesburg's most enduring industries, at times employing over three hundred people. Established in 1908 by Alvin V. Rowe (1880–1957), the company produced not only the hog oilers promoted here, but also ladders, iceless refrigerators, and garden cultivators. Possibly the company was best known for the Ro-way Doors and the Rowe Can't Sag Gates, which were produced at the plant on East Third Street until 1980.

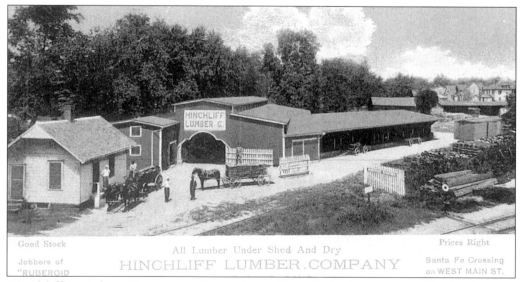

Hinchliff Lumber Company. Located on West Main Street near Maple Avenue, Hinchliff Lumber Company opened for business in the mid-1890s. In the midst of a summer heat wave in July 1916, a fire started in a small barn on the north side of the yard. The paper reported that "in a marvelously quick time the barn was enveloped in flames." The lumberyard was not a total loss, and the business survived until around 1936.

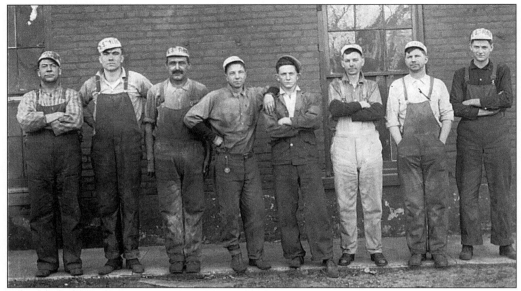

Acme Mill Hands. The Acme Milling Company promoted "complete roller process and gradual reduction fine corn meal." The mill operated east of the CB&Q depot on South Chambers Street from the 1880s. Eventually it came to be known for feed and fuel. By the late 1920s, it evolved into the Acme Coal Company. This undated photo shows an unidentified Acme Mill crew around 1910.

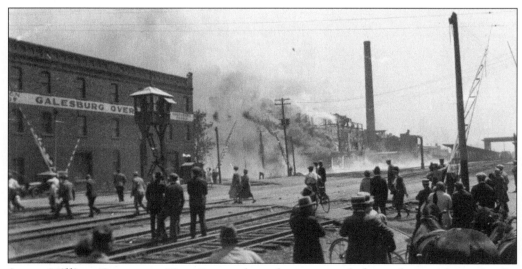

Acme Milling Company Fire. It may have been a spark from the smokestack of a passing locomotive that started the fire on June 7, 1926, at the Acme Mill at 222 South Chambers. The fire was a serious one. High winds from the west spread the fire to as many as six houses on South Chambers Street and Cottage Avenue. The Midwest Foundry to the south of the mill and even a house on Allens Avenue were involved in the fire. Firemen struggled to contain the fire, but it was so hot that, according to the newspapers, the fire hose melted. Three firemen were injured and the property loss was set at $150,000.

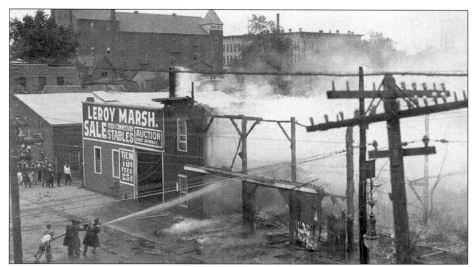

Marsh Barn Fire. The Horse and Mule Barn, which sold as many as 17,000 horses in one year, suffered a serious fire in 1913 and again, as these postcard show, in 1923. The fire began with an explosive intensity in a barn where hay was stored. The wind sent flames southwest, damaging the armory on Broad Street as well. The horses were all freed, but the financial damage was over $35,000. The business was not a total loss, however, and it wasn't until the 1930s that the barns finally closed for good.

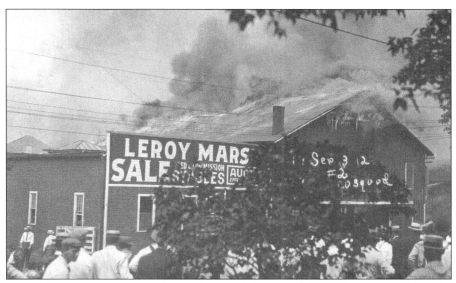

Leroy Marsh Barn. Leroy Marsh (1845–1931) learned the horse business in the Civil War, when he was 18 years old. He established the sale barn at Cherry and Waters Streets in 1871, adjacent to the railroad tracks. The business expanded (eventually to nine buildings, including stables, blacksmith shop, and a restaurant) from Cherry to Broad Street. It became the largest horse and mule barn in the world. The barn was not a sweet-smelling operation, and it was legendary in other ways as well. Supposedly Santa Fe train conductors would warn passengers to roll up the coach windows as the trains rolled into Galesburg.

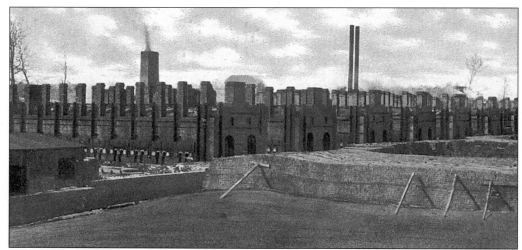

Purington Brick Kilns. A fine, slaty shale was the essential ingredient that made the hard, dense brick from the Court Creek bottom so desirable. The Purington Brick Company, established in 1890, was the most successful of the local brick companies, which were eventually absorbed into one large operation. The Purington Brick Company developed a brick works that included four separate plants outside of East Galesburg with 63 kilns and 500 employees at its height.

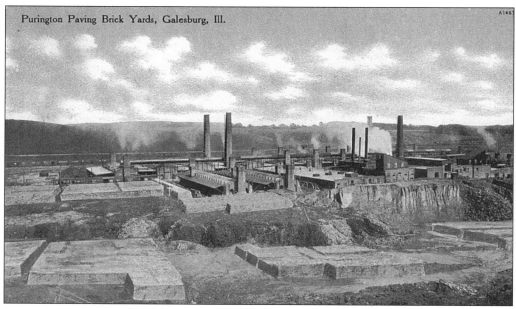

Purington Paving Brick Yards. The Purington brickyards generated an annual production of 75 million paving bricks and blocks. Vitrified paving brick—the famous Purington Paver—was sent all over the world. The newspapers noted the number of carloads of brick heading out of town like market reports, and proudly announced when "260,000 bricks were sent to Panama to be used by Uncle Sam in building his big ship canal." This view of the yard shows stockpiled brick in stacks, as well as the firing kilns. The brickyards closed in 1972.

Five
WHERE THE RAILROADS CROSS

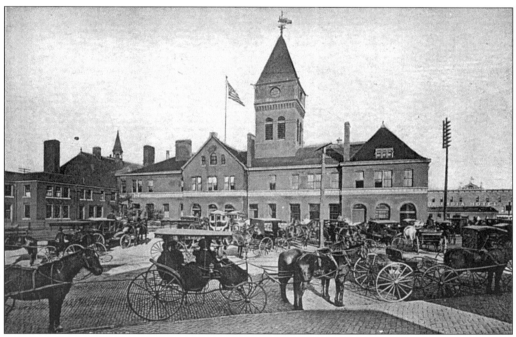

Chicago Burlington & Quincy Depot. Rail traffic in Galesburg developed in the 1850s, with an enormous financial commitment on the part of the entire community (population less than 1,500). Silas Willard (1814–1857) and Chauncy Colton (1800–1885), in particular, resolved to bring the railroad to Galesburg. Determined that the economic future of the town was dependent on rail accessibility, the investors committed a remarkable $300,000 to ensure the town's success. The Central Military Tract Railroad was the result in 1851, but it was the Chicago Burlington & Quincy that eventually formed the future of Galesburg. This postcard shows the CB&Q depot on Seminary at South Street.

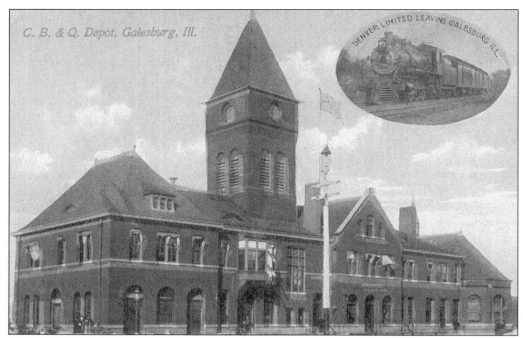

CB&Q Depot from the Tracks. The Chicago Burlington & Quincy depot, built at Seminary and South Streets, was a building of impressive size. Constructed in 1884, the station had waiting rooms, a restaurant, a hotel on the second floor, as well as division offices for Galesburg and general offices of the Illinois district. It was a testimony to the railroad presence in Galesburg, a community where hundreds of people worked for the "Q" in some capacity.

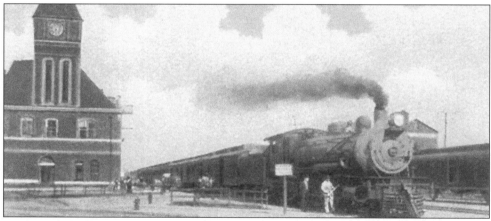

Denver Flyer. Noise and smoke dominated the arrival and departure of any train in town. Train travel was not uncommon and, in fact, it was the most efficient way to travel even short distances. Though the population of Galesburg was just less than 19,000 at the turn of the century, many trains stopped in Galesburg daily, and the CB&Q depot was a hub of activity. The *Denver Flyer* (Class S-1, 4-6-2 engine) is shown here at the depot in Galesburg (before 1911). Extra driving wheels made these new locomotives stronger than those before and won for them the name "Leviathians."

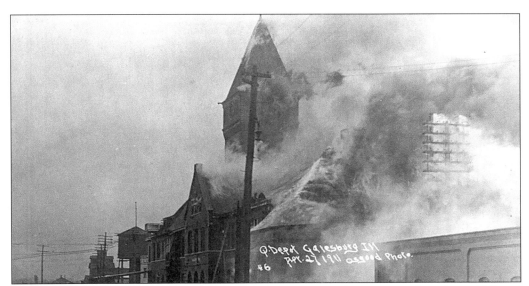

CB&Q Depot Fire. The fire that destroyed the CB&Q depot started in the middle of the day on April 27, 1911, possibly in the kitchen of the lunchroom on the first floor. It spread so quickly that two telephone operators were trapped on the third floor and had to be rescued by ladder. The offices for the Illinois and Galesburg Divisions were housed in the depot, and workers scrambled to save valuable records. Railroad operations ceased as telephone and dispatching offices were put out of commission. The depot was left in ruins, and the loss was set at $100,000.

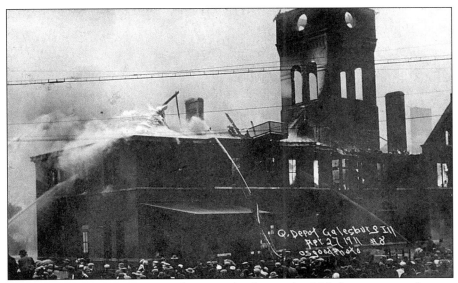

Crowds Watch CB&Q Depot in Flames. The fire at the "Q" depot was so intense that the Arlington Hotel (at South and Seminary Streets), as well as the lumberyard, which stood at that time on South Street, were hosed down to prevent the spread of the fire. Hundreds of people crowded in dangerously close to see the fire, and 45 minutes after the alarm was sounded, "the tower bearing the big locomotive [the weathervane], which had been a landmark in the city for years, collapsed."

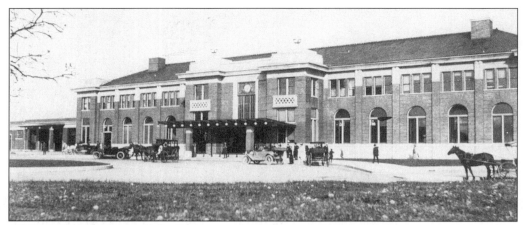

CB&Q New Depot in Galesburg. In 1913, the new CB&Q station was constructed on Seminary Street at the head of Tompkins Street, slightly north of the site of the former depot. Designed by Chicago architect Henry Raeder, the depot was faced with Bedford stone and topped with a green Spanish-style roof. The daily paper of the time said it was "suggestive of the Renaissance style." The building stood until 1983, when it was razed by the railroad—much to the dismay of many in the community who had been at work developing a reuse plan.

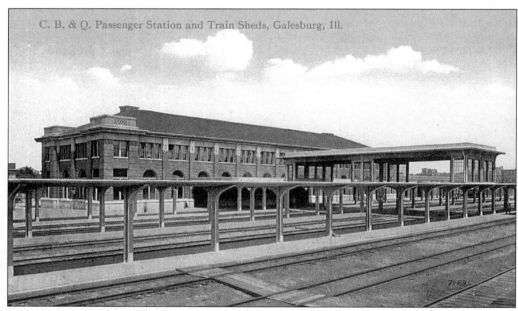

CB&Q Depot from the Tracks. The new depot was only part of a 1913 CB&Q development plan for Galesburg that included additional tracks in the uptown yard and the expansion of other facilities here. The plan provided for the track elevation and the construction of the underpass at South Street. Galesburg called itself "the most important and well-equipped division on the system." The CB&Q employed 2,500 men at locomotive and car shops, paint, wood, tin, rail, and blacksmith shops, repair yards, storehouses, lumber yard, the "hump" yard, a cement plant, and the largest railroad wood preserving plant in the country.

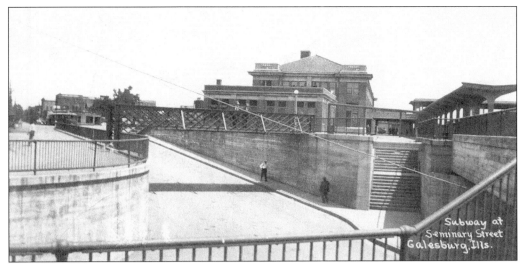

New Depot from the Subway. Seen here from the south is the CB&Q depot—or as it was more often known locally, just the "Q." The construction of the viaduct in 1913 under the tracks on South Street was a practical boon to traffic, and gave a certain big-city/urban look to the area around the depot. Residents did take a proprietary view of the construction, and ironically the sender of this card comments, "Wish you could see our new lovely depot. It sure is small."

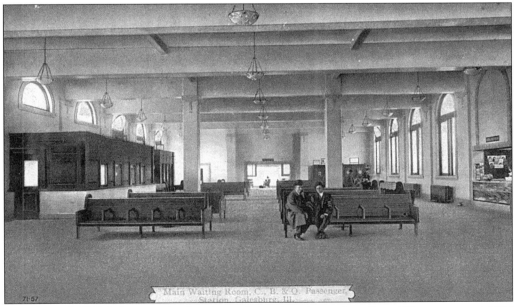

Interior of CB&Q Depot. At the time of the depot construction, 50 passenger trains stopped daily in Galesburg, and 5,000 people passed through the CB&Q station every day. The cavernous waiting room of the CB&Q station was a familiar site to many travelers from 1913 to 1983, although in its last years it was often entirely empty. Until the late 1970s, Grier's lunchroom and newsstand adjacent to this waiting room was open at all hours for travelers and residents alike.

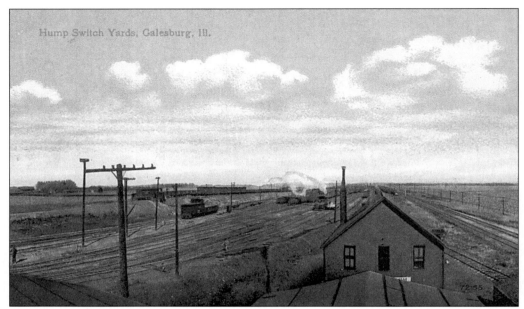

Hump Yards in Galesburg. The investment of the 1850s paid off, and Galesburg became a huge freight center, developing the gravity-switching yard known as "The Humps." The first hump on the east side of the yard, on the left in this postcard, was built in 1906. In the first half of the century, the rail yard in Galesburg was described as the largest of its kind in the country. Manually operated until 1931, the hump yard was significantly modernized with the addition of pneumatic retarders on the tracks to control the speed of the freight cars.

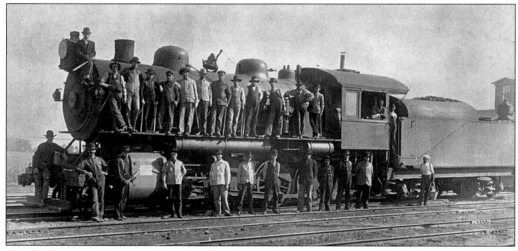

Work Crew on Locomotive. Work trains and crews like these built the east hump in 1907. Maintaining the rail service and machinery of the trains in the Galesburg yards required a huge work force. Day and night, the yards and the depots were alive with activity. During the first decades of the 1900s, nearly every week the local newspaper told the tragic stories, in graphic detail, of men injured or killed at work in the rail yards. Even as late as 1947, one in six people in Galesburg worked for the Burlington.

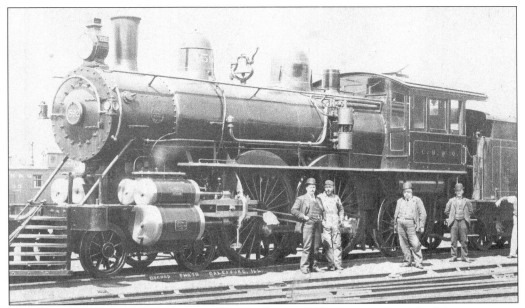

Standing in Review with Locomotive #1592. These important-looking men are standing in front of the #1592, an engine that evolved from the Columbian Exposition engine, which made the record-breaking fast mail run on February 17, 1899, from Chicago to Council Bluffs, Iowa, in 9 hours, 14 minutes. The engine pictured here with a redesigned, more stable front wheel assembly, was a type of engine that came to be known to the railroad world as the "Greyhounds of the Burlington."

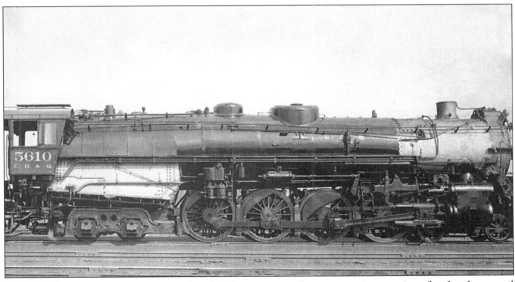

The #5610 in May 1937. In the 1930s, expectations were increasing for both speed in passenger travel and pulling power in freight business. A new class of engines was created to meet the demand for fast freight or heavy passenger service. It was the Class O-5 Northerns that were the dual purpose, workhorse engines. They were strong and fast enough to outrun the Zephyrs.

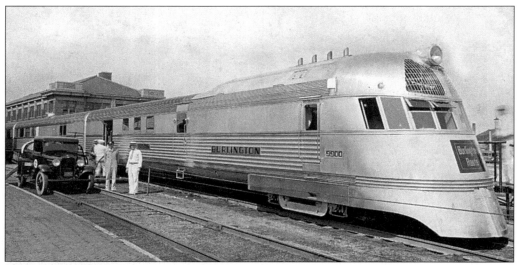

Pioneer Zephyr. The *Pioneer Zephyr* was all a train could be—modern, fast, and beautiful. Created in 1934, the lightweight locomotive produced clean electric diesel power in a gleaming, smooth machine. The train was truly the Silver Streak—and fast! On May 26, 1934, the *Pioneer Zephyr* made the record-setting 1,015-mile non-stop run from Denver to Chicago in 13 hours and 5 minutes. The top speeds of 112.5 mph were remarkable. In 1960, 25 years after its initial run, the *Pioneer Zephyr* was placed on permanent exhibit at the Museum of Science and Industry in Chicago.

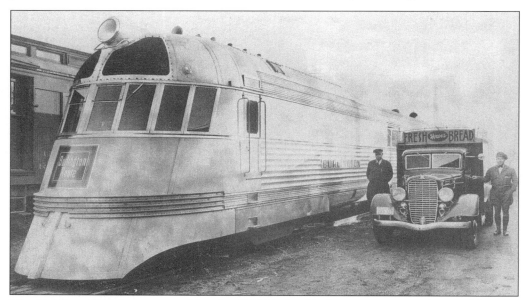

The Zephyr. Widely promoted by the CB&Q, the *Zephyr* was an attention-grabber. Its dramatic, sleek look heralded changes in the design of everything from airplanes to toasters. When the *Zephyr* toured Galesburg in June 1934, almost 4,000 people squeezed through the train in three hours, and hundreds of others were turned away. Local businesses along the railroad corridor, like the Howe Bakery in Galesburg delivering fresh bread, were eager to capitalize on the glory.

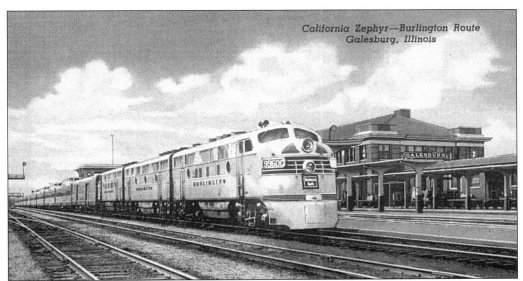

Eastbound *California Zephyr* Stopping in Galesburg. The Electo-motive, Class F-3, 9960 AVC was built in 1949 to be used for the new *California Zephyr*. Scheduled to pass through the most dramatic scenery in the nation during the day, when passengers could appreciate the view on a train intended for enjoyment more than speed. Air-conditioned coaches and new Vista-dome seating made travel on the *California Zephyr* a pleasure trip. Shown here in the late 1940s at Galesburg, the *Zephyr* delivered passengers from Chicago to California in just over 50 hours.

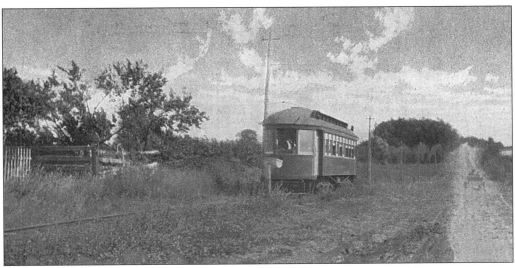

Interurban Travel. Electric interurban railcars, a bit more substantial than streetcars, carried passengers and often mail and packages to other towns near Galesburg. At the turn of the century, three different lines would take riders to Abingdon, Knoxville, and Monmouth, then on to the Rock Island. This car, on its way to Abingdon (The People's Traction Company), would have picked up passengers at a waiting room on the south side of Simmons near Prairie Street and the Public Square. The lines were discontinued in the 1920s for passengers, although some freight traffic continued into the 1950s.

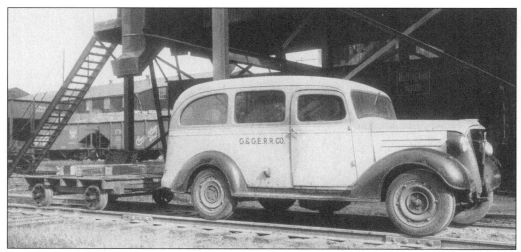

Galesburg and Great Eastern. The Galesburg and Great Eastern was established in 1898 as a passenger and freight line between Wataga and Victoria, and on to Etherley, a mere 10 miles or so. Its purpose was to move coal from the strip mines near Victoria, but the "Go and Go Easy," as it was sometimes called, moved people too, in this modified Chevrolet. In spite of its name, the G & GE never made it to Galesburg, and the line was abandoned in 1961.

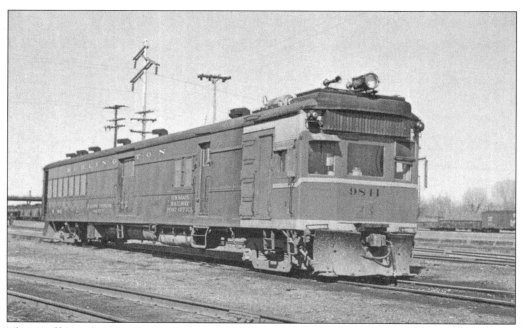

The *Dolly*. A diesel rail motor car such as this one, sometimes called a doodlebug, was used for short runs carrying passengers and mail. Initiated in the 1920s, the Burlington had the largest fleet of such cars and made use of them for more than 40 years. This view in Galesburg in the mid-1960s, of a run to Peoria, was taken shortly before the use of the unit was discontinued.

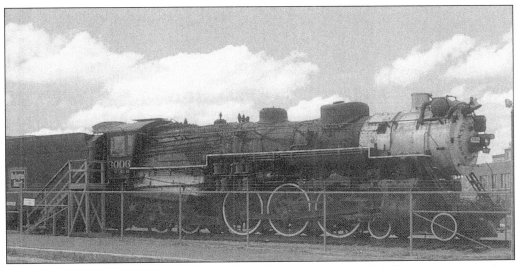

Galesburg's Own Locomotive. The #3006 locomotive, an S-4 Hudson-type engine, was built in 1930 by Baldwin. It was donated to the City of Galesburg in 1961 by the Burlington Railroad. Acclaimed for beauty and proportion, it was a powerful, fast passenger engine. The locomotive is the anchor of the rail museum here and is on display just north of the Amtrak depot on South Seminary Street.

The *Meath*. The Galesburg Railroad Museum at Seminary and Mulberry Streets is comprised of the #3006 locomotive, a Railway Express/Railway Post Office mail car, a caboose, and the *Meath*, a former Pullman car. The engine and cars create a unique glimpse at railroad history and are central to the city's annual Railroad Days festivities every June. On site since 1980, the *Meath* has been reworked inside for the display of photos, documents, and memorabilia.

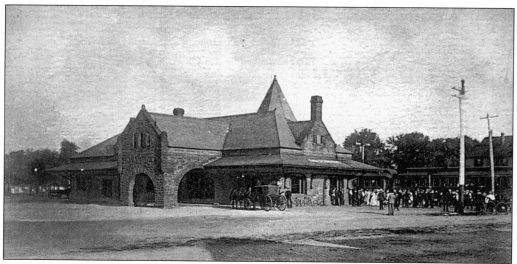

Santa Fe Depot. In 1887, the first train came through town on the Santa Fe line. The red sandstone Santa Fe passenger depot, seen here from the south, was constructed in 1888 on North Broad Street, where the railroad tracks run parallel to Cedar Creek. The depot was made of rough-cut red sandstone, a slate roof, and an octagonal tower on the north side. The design included separate waiting rooms for men and women, each with its own lunchroom. Until it was demolished in 1966, the doors to the waiting rooms remained marked, one for men and one for women.

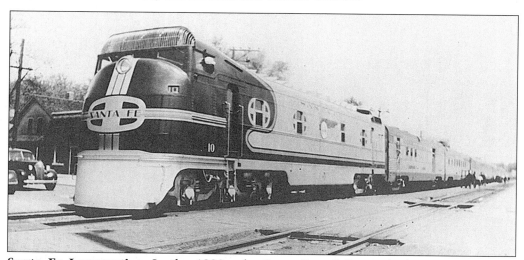

Santa Fe Locomotive. In the 1880s, the Santa Fe rail line, which ran to the west, sought to extend its route from the Mississippi River to Chicago. Initial Santa Fe plans were to bypass Galesburg, but the persuasive efforts of Clark E. Carr (1836–1919), W. Seldon Gale (1822–1900), J.T. McKnight (1837–1912) and others, as well as the financial contributions of local entrepreneurs, insured the route through Galesburg. When this view of the *Super Chief* was taken in the 1940s, Galesburg was one of an exclusive number of communities that could boast more than one railway line. Galesburg was a town where the railroads cross, and this is a distinction held until the Burlington Northern and Sante Fe rail merger in 1995.

Six
SUNDAYS IN GALESBURG

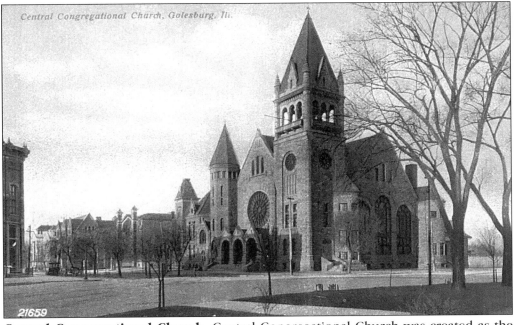

Central Congregational Church. Central Congregational Church was created as the union of the First Congregational Church and the Old First Church. The building itself was constructed in 1897 by Galesburg architects J. Grant Beadle (1865–1929), and Charles E. Gottchalk. Famous for its Richardsonian Romanesque architecture and remarkable rose window, the church was named to the National Register of Historic Sites in 1976. This site on the Public Square was that of the first meeting house in Galesburg known as the First Church. Built in 1846, Old First was the church of the founders who were both Congregationalists and Presbyterians.

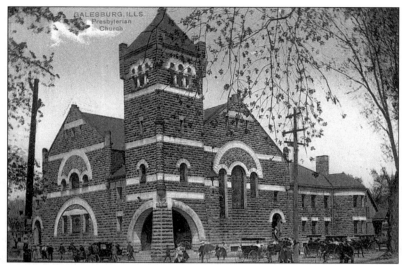

First Presbyterian Church. The Presbyterian Church at the corner of Ferris and Prairie Streets represents in some ways the oldest congregation in Galesburg. The town founders were not all the same denomination, but by agreement of the congregation, the first church established in 1837 was the Presbyterian Church of Galesburg. The initial congregation grew, changed, moved, and divided over the years. This building, following the design of Norman K. Aldrich (1856–1933), was constructed in 1893. The church was the union of the Old School Presbyterian and the Second Presbyterian Churches, and organized as the First Presbyterian Church.

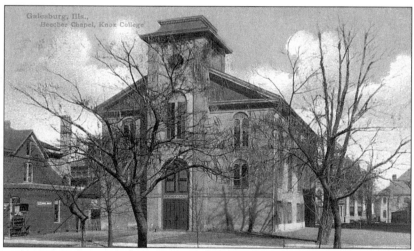

Beecher Chapel. A group with strong abolitionist feelings from the Old First Church established the First Congregational Church in 1858. They built their church on South Broad Street, north of Whiting Hall. The first minister was Edward Beecher, from the famous Beecher family and brother of Henry Ward Beecher and Harriet Beecher Stowe. When the congregation united in the Central Congregational Church in 1890s, the Brick Church, as it was often called, was purchased by Knox College. Thereafter it was known as Beecher Chapel. It was used for college gatherings and as the home of the Knox College Conservatory of Music. Sadly, it was razed in 1966.

East Main Congregational Church on Phillips Street. As part of an outreach program of the larger church, two churches were established in 1894—the Knox Street Congregational Church at Knox and Day Streets, and the Union Congregational Church on Phillips Street. The building pictured on this postcard was the chapel, which stood just west of the Old First Church. It was moved to the west side of Phillips Street near East Main. The chapel served the Union Church congregation, or as it came to be called, the East Main Street Congregational Church, until their present building was constructed in 1910.

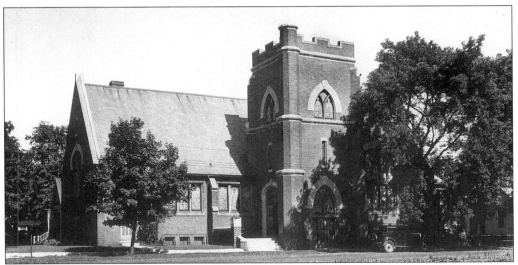

East Main Congregational Church. East Main Congregational Church was one of the first churches on the east side of town and took pride when it became known as the "Neighborhood Church." This building, at the corner of East Main and Whitesboro Streets, was dedicated in December of 1910. The still-strong, active church has evolved to become the United Church of Christ. The sanctuary is distinguished by the work of Galesburg sculptor and teacher, Jimmie Crown (1933–1987).

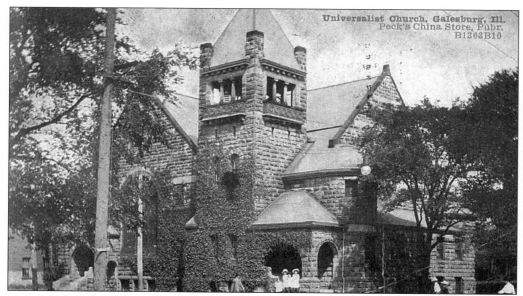

Universalist Church. The Universalist Society was organized in 1855, and established itself as the supporting arm of the new Lombard College. This church on the northeast corner of Prairie and Tompkins Streets was the design of Galesburg architect Norman K. Aldrich (1856–1933). Completed in 1894, the new building, which could seat 800 worshippers, was supported by a strong and vital church until the 1930s. The closing of Lombard was a serious blow, but the Universalist Church remained active until the 1960s. In 1963, the church was sold and demolished for a parking lot.

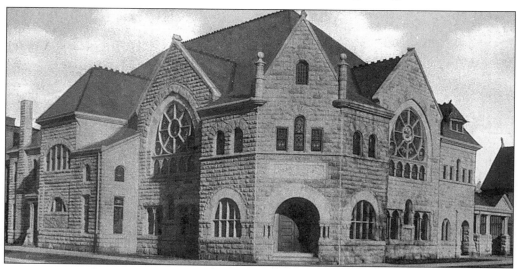

First Baptist Church. The First Baptist Church was transferred from Knoxville to Galesburg in January 1848, and in 1852 the church building was on South Broad and Tompkins Streets. The church pictured here at Cherry and Tompkins Streets was built by Galesburg's most distinguished architect, William Wolf, in 1894, with seating for nearly 800. It replaced a frame church that was lost to fire in 1892. The church recently celebrated its sesquicentennial.

First M.E. Church. Ten years after the founding of the town of Galesburg, the Methodist Episcopals established a small church on the northeast corner of Kellogg and Tompkins Streets (1847). Peter Cartwright (1795–1872), the formidable, itinerant Methodist clergyman, preached the dedicatory sermon in November 1853. After that church was sold and moved in 1872, the congregation began to build this elaborate new church on the same site. Services were held in the basement until the entire church was completed. The imposing gothic building was dedicated in 1876. The tower of a building at the Brown Cornplanter Works is visible behind.

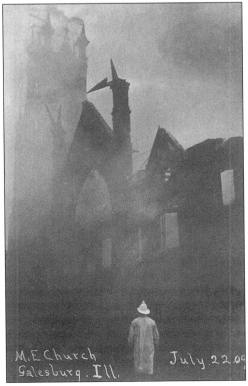

First M.E. Church on Fire. The fire at the Methodist Episcopal Church in July 1909 was well established when it was discovered. Low water pressure and high winds complicated the work of the city firemen, who were joined by the fire crew from the CB&Q rail yards. Though it was agonizing to watch, thousands crowded the corner to see the fire. Possibly caused by poor wiring in the attic, the fire spread quickly throughout, and the impressive tower was the last to go. It was reported that heat and drafts of the fire cause the pipe organ to wheeze with a ghostly song.

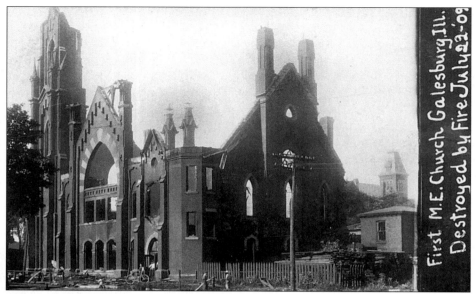

First M.E. Church in Ruins. The day after the fire, members of the M.E. Church met to begin plans for a new building. Immediately, contributions were offered. While the walls remained standing, the church clearly could not be salvaged. In addition, the neighborhood was becoming increasingly industrial and commercial, and the church membership was moving north within the city. It was decided the congregation would be moved to property on which a larger church could be built. The tower on the right is that of Corpus Christi Lyceum.

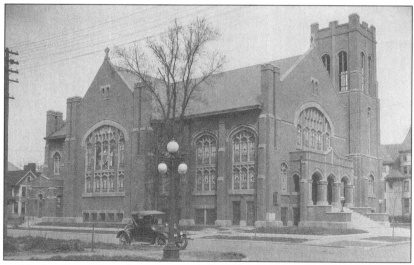

The First Methodist Church. In 1911, the cornerstone for the new M.E. Church (designed by architect Norman K. Aldrich), was laid at Kellogg and Ferris Streets. Two years later, the new church was dedicated before an estimated audience of 1,500 (650 in the sanctuary, 350 in the balcony, and 500 in adjacent Sunday School rooms). For nearly 85 years, the church has grown, modernized, and expanded to include a chapel and a two-story educational wing.

Swedish Lutheran Church. The Swedish Lutheran Church was built in 1850, even before the congregation was officially organized in August of 1851. The church pictured here replaced the first building, and served the congregation from 1869 to 1926. It was on the corner of Waters and Seminary Streets, and the spire rose 165 feet. The first minister was Tuve N. Hasselquist, (1817–?), who also founded the first Swedish language newspaper in the United States, *Hemlandet*, published in Galesburg from 1855 until it was moved to Chicago in 1859.

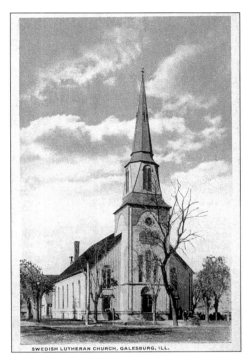

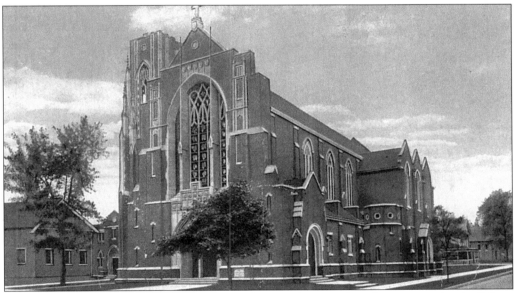

First Lutheran Church. When the Swedish Lutheran Church outgrew its building, Adolph Hanson of Chicago was the architect chosen to design the plan for the First Lutheran Church of Galesburg. The new church was built at Seminary and Waters Streets, and was completed in 1928. Dramatic inside and out, the church, its "pure gothic design" and its "lofty façades" are described in detail in the dedication book. The stone panel above the entry was designed by Galesburg resident and church member, Ruth Dahlberg Bengston.

FIRST SWEDISH LUTHERAN CHURCH PARSONAGE
GALESBURG, ILLINOIS

Lutheran Church Parsonage. In an architectural manner quite different from that of the church itself, the Prairie-style parsonage of the First Lutheran Church was built in 1914, on a lot south of the church site. Describing itself in some publications as the Swedish Lutheran Church even as late as 1941, the congregation heard sermons in Swedish far into the twentieth century.

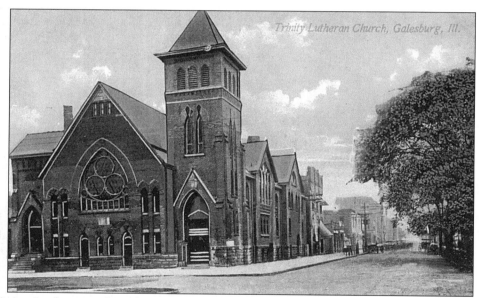

Trinity Lutheran Church. Trinity Lutheran Church now stands at Ferris and Kellogg Streets. In 1906, the church was organized by members of the First Lutheran Church congregation who wanted their services to be in English rather than Swedish. The building in this view was formerly St. John's Episcopal Church. Since it was purchased by the Trinity congregation in 1907, it has been remodeled and expanded a number of times. This postcard shows the view from Ferris Street looking down Kellogg toward Main Street.

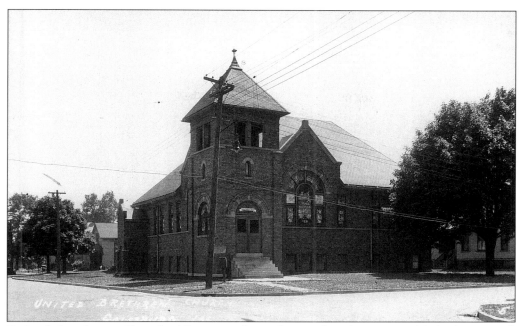

United Brethren Church. The United Brethren Church was established in 1906, initially meeting in a room on Main Street. Soon the congregation began meeting in the former East Knox Street Congregational Church, at the southwest corner of Knox and Day Streets. The church was lost to a fire in 1908, and the building on this postcard was constructed on the site of the former church in the same year. Since then the church has evolved, replaced the 1908 building with a new one, and today has become the Faith United Methodist Church.

Mission Covenant Church. A group of Swedish Lutherans who separated from the First Lutheran Church organized their own church in 1868. First known as the Second Lutheran Church, it later became the Swedish Evangelical Lutheran Church of Galesburg, then finally the Mission Covenant Church. This building at 373 East Simmons Street was the home of the church from 1869 until 1961, when a new church was built on Jefferson Street. The Simmons Street church was later the home of the Bethany Baptist Church, and then the Prairieland Baptist Church. It was razed in 1986.

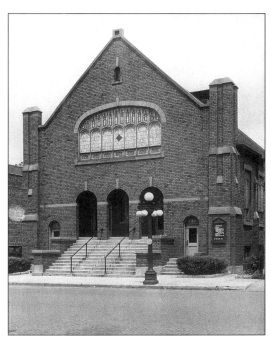

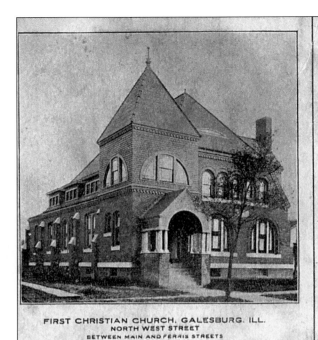

First Christian Church on West Street. Organized in 1872, the First Christian Church congregation met originally in a building on Ferris Street. In 1891, the congregation purchased a lot at 65 North West Street. The building constructed there was dedicated in 1892, but soon proved too small for the growing congregation. In 1908, property was purchased on North Broad Street for a new church, but the building pictured here on West Street was the church home for several more years.

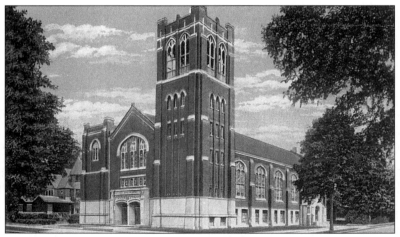

First Christian Church. The initial portion of the First Christian Church, which still stands at the northeast corner of Broad and North Streets, was constructed in 1915. Norman K. Aldrich was chosen as the architect for an additional larger church, which would incorporate the old into the new design. The Gothic exterior is of Bedford bluestone and Purington brick. At the time of the dedication in 1928, the church was well known for its musical ministry and distinguished for its organ and tower chimes.

Corpus Christi Church. The first Catholic mass in Galesburg was held in 1855 in a blacksmith's shop. Some time thereafter, St. Patricks Church was constructed on South Academy Street (dedicated in 1863). The church was to support an area Catholic population that was said to be nearly a thousand. Father Joseph Costa (1823–1917) arrived in Galesburg in 1877, and began a spiritual and educational movement that is sustained today. Pictured here is Corpus Christi Church, a key part of Father Costa's plan for Galesburg. This church was completed in 1885 at the corner of Kellogg and South Streets, at a cost of $45,000.

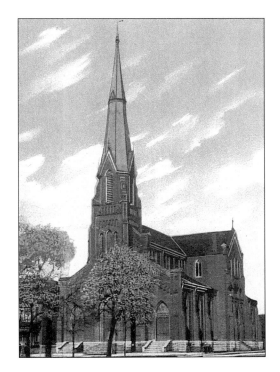

Corpus Christi Church Interior. The construction of Corpus Christi Church on South Prairie Street was supervised by Father Costa. It remains today as an essential element for the Catholic community in Galesburg. The building has been recognized for its architecturally dramatic interior. The marvelous stained glass windows depict St. Michael, St. Rose of Peru, and St. Francis of Assisi among others. As a result of Father Costa's efforts in 1887, the church houses the remains of St. Crescent, a child martyred in the 3rd century A.D.

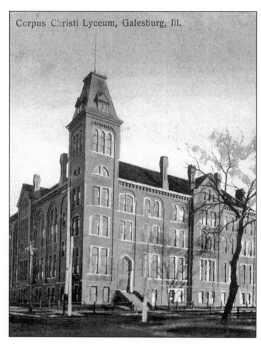

Corpus Christi Lyceum. Corpus Christi Lyceum was established in 1893. The school, at the southeast corner of Tompkins and Prairie Streets, provided Catholic education for high school and college-age men. Corpus Christi served as a co-educational high school after 1948, when older students were transferred from St. Joseph's Academy. After the construction of Costa High School in 1964, Corpus was closed and demolished in 1966.

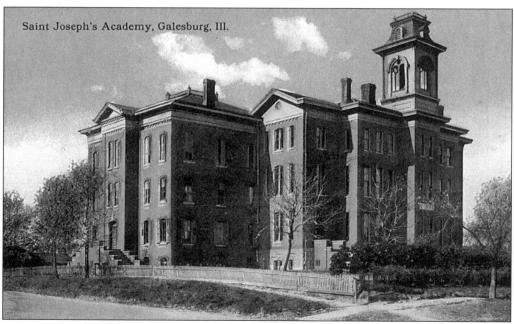

St. Joseph's Academy. St. Joseph's Academy was built in 1879 in the 500 block of South Academy Street. The school began with an enrollment of nearly three hundred students, and was supervised by the Sisters of Providence of St. Mary's of the Woods. St. Joseph's served first as a high school and grammar school. Later St. Joseph's was used only as an elementary school, closing in 1972. The building was eventually sold to the Bethany Baptist Church. After several more years as a church school, it was razed.

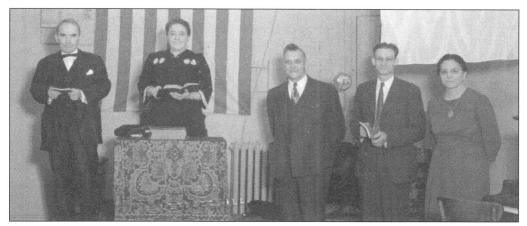

Rescue Mission. Nestled in a row of taverns on the southeast side of the Public Square was the Rescue Mission, with a big, white, lighted cross in front. The Mission was dedicated in 1941 by Mrs. Billy Sunday, and was the ongoing work of Josephine and Sylvester Sanford. Evangelist Sanford developed a national reputation and became known as "the man of a thousand songs." The Sanfords provided music and salvation, food, and a bed 365 days a year to men in need. The Mission remained to help the wanderer, until progress and urban renewal cleared the corner.

Sanford Revival. A promotional postcard mailed by the Sanfords reads as follows: "Fire Marine and Life Insurance. Are you insured in the King's Insurance Company? It is the oldest in the world. It has never changed management. It is the only company insuring against shipwreck on the Ocean of Life or in the River of Death. It is the only company insured against loss in the great Judgement Day Fire. The President of the Company is Christ the King of Kings. Home office: Heaven. Persons having no soul need not apply! First premium: Salvation; second: Membership paid in full and a home in Heaven. Personal Representatives: Evangelist & Mrs. Sylvester Sanford."

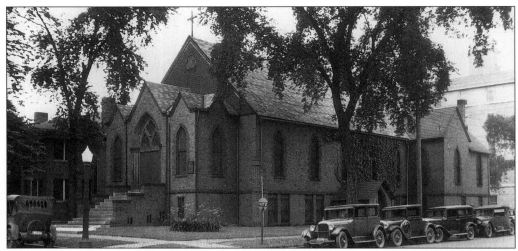

Grace Episcopal Church. Grace Episcopal Church, pictured above, was organized in 1858. The first service in the church home at Prairie and Tompkins Streets was held on Christmas Day, 1860. In 1935, St. John's Episcopal Church—a congregation which the newspaper reported was "made up entirely of Swedes"—joined with Grace Church. In 1970, the church moved to a new location on Carl Sandburg Drive. The old church was then razed, but architectural treasures of the original church were incorporated within the new building.

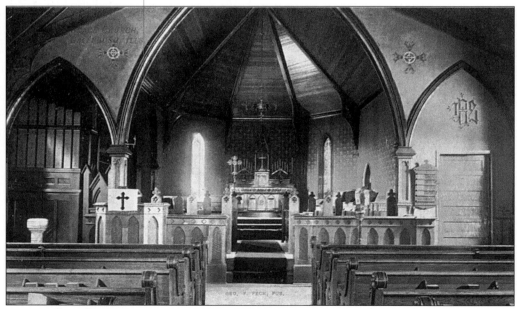

Grace Church Interior. The first minister of Grace Church, Rev. W.T. Smithett, was brought from Boston to serve both Knoxville and Galesburg. He would preach here on Sunday and then walk to Knoxville for services there. The following week he would reverse the procedure. During the Civil War, Rev. J.W. Cracraft incited such discord in the congregation over abolitionist issues that the church doors were barred by the bishop. No such headlines have distinguished the church since.

Seven
HAVING FUN—WISH YOU WERE HERE

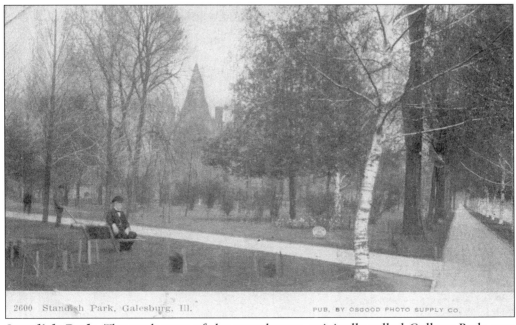

Standish Park. The park west of the courthouse, originally called College Park, was named for Dr. John Van Ness Standish (1825–1919), long-time Lombard College professor and arborist. Dr. Standish was influential in planting the park, which was celebrated more as an arboretum, with spectacular plantings and unique examples of fine trees. He assisted in planning and planting both the Knox and Lombard College campuses, and indeed the entire city. In addition, he promoted acquiring the property that eventually became Lincoln Park. In this view, it is Dr. Standish himself sitting in the wheelbarrow in the park.

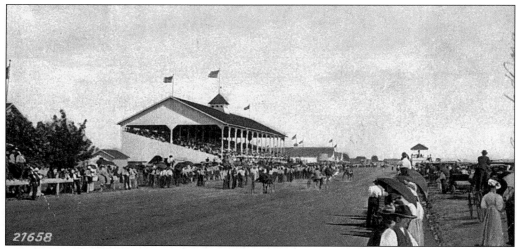

Galesburg Driving Park. The local paper broke the news that "a syndicate composed of a few capitalists of the place" had the intention of creating a first-class racetrack. That plan grew into the Galesburg Driving Park, also known as the Dead Level Track, and much later called the District Fair Grounds. In 1894, the 1-mile track was laid out in the area between Grand Avenue and Farnham Street. The track was used primarily for horseracing, although bicycles and motorcycles were also raced there. It was reportedly the site of the first automobile race in the country in 1899.

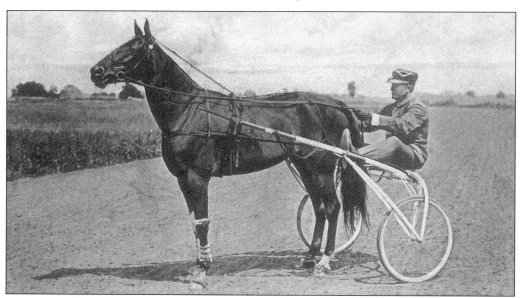

The Bronco. The Dead Level Track was laid out under the direction of C.W. Williams (1857–1936), a flamboyant horse-breeding and racing entrepreneur from Independence, Iowa. Mr. Williams was brought here at great expense to set up and operate the track. The local legend is that he was later won over by the evangelist Billy Sunday, and gave up life in the fast lane for good. The Bronco, pictured on this postcard, made a speedy impression on August 24, 1906, by running the mile in 2.75 minutes.

YMCA on Prairie Street. The Young Men's Christian Association was organized here in 1885. "The Y" utilized makeshift quarters until 1897, when construction was begun on the building at 49 North Prairie Street. William Wolf was the architect, and his plan included meeting rooms above first-floor stores. An early tenant was G.B Churchill's Hardware, and much later Gale Ward Sporting Goods. The gymnasium was in a separate building behind, connected by an interior corridor. Later this building was sold to the Masonic Lodges, who made significant changes to the exterior. The buildings are still standing, and in the 1990s, they were adapted for use as offices and a radio station.

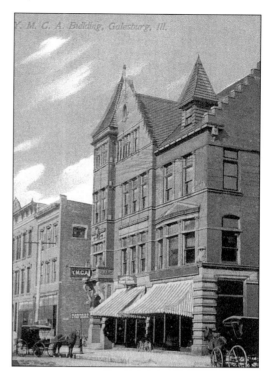

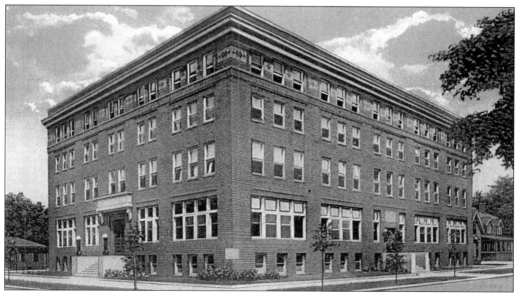

YMCA on Ferris Street. A new Young Mens Christian Association building was constructed in 1915 at 383 East Ferris Street. This view shows the new YMCA, which included recreation and meeting rooms, a gymnasium, a swimming pool, and residential rooms on the upper floors. The Ferris Street building was used until 1977, when a north-side YMCA was constructed on West Carl Sandburg Drive. The former Ferris Street YMCA was then converted into apartments.

KEEP THIS IN SIGHT

Greeting from the Galesburg Woman's Club

The Junior Civic League has now about 2,500 members. Men and women as well as children can help to keep our CITY clean by observing its rules:

1. DO NOT throw down any PAPER
2. DO NOT throw down any FRUIT
3. DO NOT throw down any RUBBISH
4. DO NOT hurt any PROPERTY
5. OBSERVE all City ORDINANCES

William Penn Maxim

"Love Labor; for if thou dost not want it for food, thou mayest for physic. It is wholesome for thy body and good for thy mind."

Municipal House-cleaning, April 23-30, 1914

To get any results, everyone must help. You should do this not only for yourself, but for your neighbor as well. In return your neighbor should help you. Disease is an enemy of happiness, but cleanliness is an enemy of disease.

DR. JOHN D BARTLETT.
Commissioner of Health.

Galesburg Women's Club. In the late 1800s, women's literary and social clubs began to develop nationwide. Galesburg had its share—Hawthorne, Sorosis, Fortnightly, and Clio Clubs, among many others. The Galesburg Women's Club, formed in 1911, placed an emphasis on the performance of good works, rather than purely intellectual improvement. Its members concerned themselves with matters of the home, nursing and sanitation, and civic issues, as well as something delicately called "the study of child conservation."

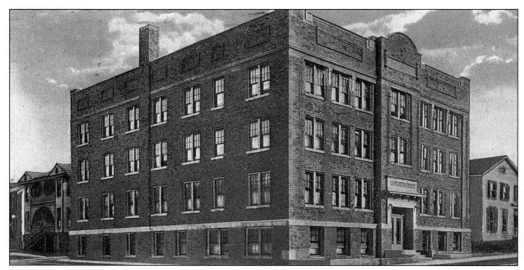

Catherine Club. With roots in the Galesburg Women's Club, the Catherine Club at Prairie and Waters Streets was built in 1917 to offer guidance and security for young women needing a place to live when working in the city. The residents had to be employed and subscribe to a code of good moral conduct. All who stayed here were supervised by the housemother in residence. The Catherine Club organization and the construction of the building were the results of a determined group of women who operated the home until the mid-1970s, when the units were converted to apartments.

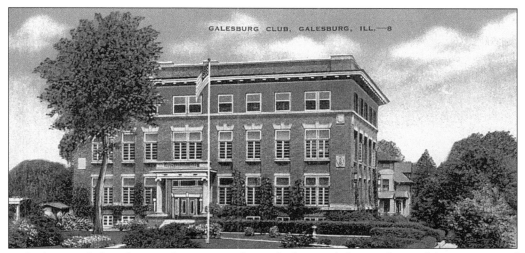

Galesburg Club. Chartered in 1885, the Galesburg Club was formed by a group of businessmen to bring business and industry to Galesburg. The club's first quarters were in the Bank of Galesburg building on Main Street, but this building, sometimes called the Civic Center, was constructed in 1911 on the northwest corner of Ferris and Prairie Streets. For years it was the center of festivities and negotiations of all kinds. There were clubrooms and restaurants for the members and residential rooms as well. Times change though, and the club closed in the early 1960s, and the building was razed before the end of the decade.

Galesburg Boosters. Enterprising businessmen and merchants decided to spread the good word that the town was a fertile environment for development, and a place of possibilities. In the fall of 1915 they began a "monster booster campaign," and 30 representatives of retail and industry set out for the towns within a 50-mile radius. Accompanied by a band (and singers) and dressed in white linen dusters and caps to match, the Boosters would parade into a neighboring town. They would make speeches promoting Galesburg's potential, and then hasten on to the next stop. The Galesburg Club is pictured behind the Boosters.

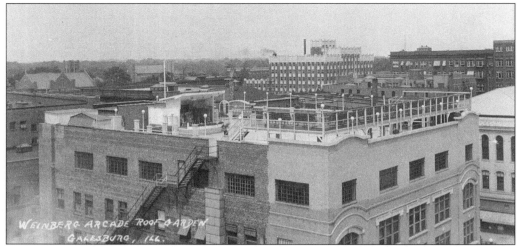

Weinberg Arcade Roof. The arcade roof was opened on the third floor of the new Weinberg Arcade, at the corner of Prairie and Simmons Streets, in July 1925 by Harlan Little (1890–1971) and W.R. Allensworth (1888–1972). Their ballroom above the West Theatre next door had been a success for 15 years. Taking the dancing outside under the stars was a "can't-miss" proposition. The newspaper said the roof gave an appearance of an Italian garden with stately pillars. The dance floor was marble, and the ads loftily announced that Arcade Roof was "where the sky begins."

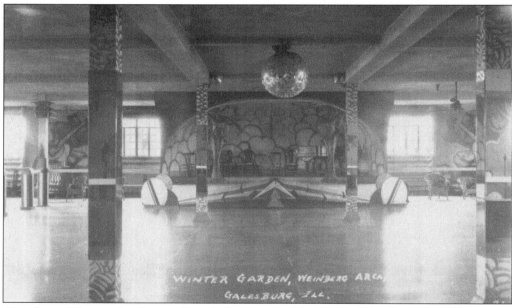

Weinberg Winter Garden. A fourth floor was added to the Weinberg Arcade in 1929 to accommodate the Winter Garden, a ballroom for all seasons. At the gala opening, guests were delighted with the band shell "of the modern type," installed and detailed by decorator and architect, Don Gullickson (1905–1979). The Galesburg Roof Garden was one of a string of such ballrooms in Illinois and Iowa operated by Mr. Little and Mr. Allensworth.

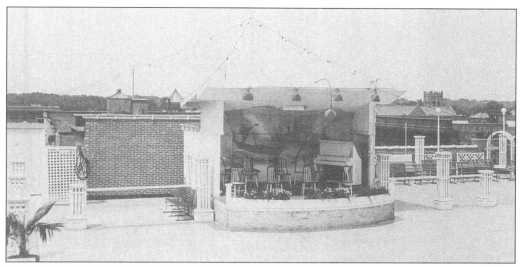

Weinberg Summer Garden. On hot summer nights before air conditioning was common, crowds would flock to the Summer Garden to listen to music, dance, and catch the breezes four stories up. The garden was open Thursday, Friday, and Saturday evenings, as well as Tuesdays for dance lessons. The Roof Garden admission was 25¢ for ladies and 40¢ for gentlemen. Ads of the time declared "You're missing fun and a sociable evening when you fail to acquire the 'Roof Habit.' Four thousand gay folk danced at the Roof in April. There is a reason!!"

Tucker's Night Owls. For 25 years, people came to the Roof Garden from miles around to hear fine music and dance the Charleston, the Fox Trot, and the Lindy in turn. Musicians such as Lawrence Welk, Jimmy Dorsey, Kay Kyser, and Paul Whiteman played them all. The largest crowd—over two thousand—came to hear Carl Deacon Moore. But it was often the local bands—Frenchy Graffouliere, Casey Jones, Larry Haggerty—that were among the favorites. Another hometown band, Tucker's Night Owls, are pictured above. It was local favorite Mabel Ronstrum's Band that was the headliner the night the Roof Garden opened in 1925.

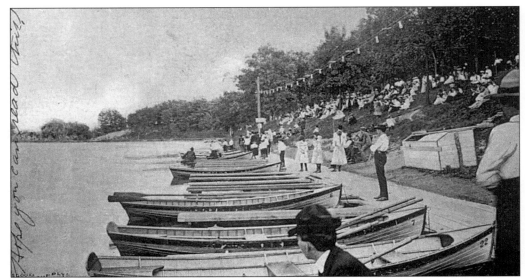

Highland Park. Now known as Gale Lake, Highland Park—just a 5¢ streetcar ride to East Galesburg—was a gathering place for college regattas, revivals, and Chautauquas. There was a picnic area, a bathhouse, a dock, and a bandstand for concerts. There were boats, and even donkeys for hire. Built by the CB&Q Railroad in the 1870s, the park has since been owned by Galesburg Power and Light, Gale Products, and now by the town of East Galesburg.

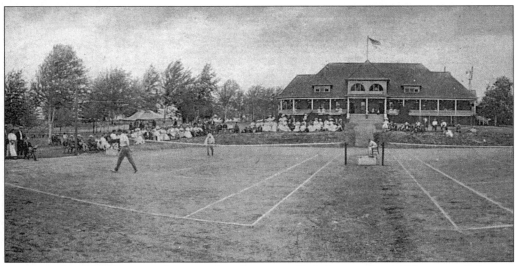

Soangetaha Clubhouse. Soangetaha Country Club began in 1888 as an informal men's club for those who were interested in the new fad of golf. The first clubhouse, adjacent to the new golf course, burned to the ground in 1895. This building pictured above, facing Lake Rice, was built to replace it. The lake was first known as Lake George, named for G.W. Brown, who sold it to the CB&Q. In the 1960s, it was transferred to Knox College, who sold the property to Soangetaha Country Club.

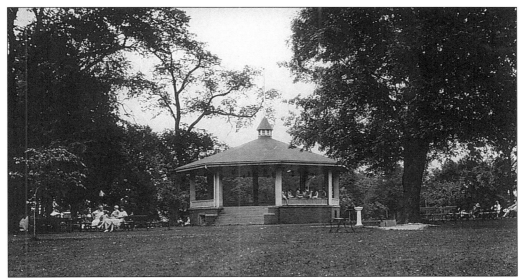

Lincoln Park Band Shell. The bandstand at Lincoln Park was the site of many musical events, speeches, parties, family reunions, and weddings. This area was known to early settlers as "First North," the first woodlot north of town. The initial 78-acre parcel was purchased in 1906 by the city to be developed into a park for all. One history reports that the purchase was "thought by many [to be] an act of useless extravagance." Now more than doubled in size, the park and golf course are clearly a community asset.

Lincoln Park Bear Cage. It was not uncommon in the middle of the twentieth century for parks, even in small cities, to maintain miniature zoos where animals were kept for public viewing. The bear cage, constructed in the early 1920s, was in the area just west of the playground at Lincoln Park. The cage served as an intriguing lure for children, even after enlightened city officials had the bears removed. Eventually, the cages were removed altogether.

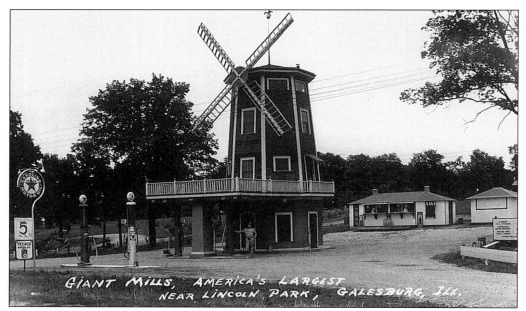

Giant Mill. The Giant Mill fits into an architectural catchall category called "Roadside America." California had a drive-thru donut shop in the shape of a donut. Peoria had an ice cream stand in the shape of an irresistible cone with a window in it. Galesburg had the Giant Mill—"America's Largest"—near the west entrance to Lincoln Park. The gas-station-in-a-mill was selling gas for something just over 5¢ a gallon. Lumber for the construction came from H.L. Hansen, and Oscar Anderson was the carpenter. The machine work was done by Thomas E. Johnson using Timpkin Roller Bearings.

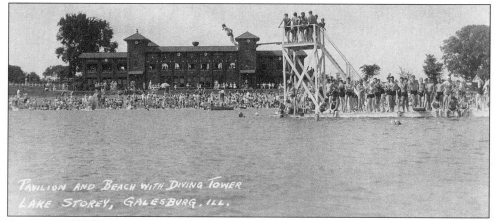

Lake Storey Pavilion. The Santa Fe Railroad constructed Lake Storey in 1929 as a water supply for steam engines and named it for W.B. Storey, the president of the Santa Fe System from 1920–1933. The pavilion and beach were dedicated in September 1930. Architect N.K Aldrich (1856–1933) designed the pavilion to be symmetrical, presenting the same profile from the beach and from the road. The building included a large covered porch and a large assembly room, as well as dressing rooms, a lunch counter, and caretaker's suite. The pavilion is still in use today and remains essentially unchanged.

Eight
Main Streets—Your Streets

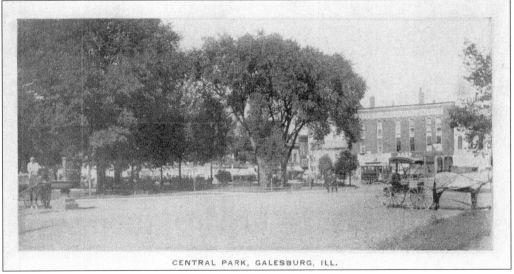

Central Park. The park in the center of the square is known as Central Park. It was part of the original plan for Galesburg, which was devised in New York before the settlers ever set foot on the prairie. The Public Square and the park were the center of schools, churches, and commerce for the town for some time. Gradually, however, commercial interests developed to the east. This view shows a park full of trees, a water trough for horses to the right, and the southeast corner of Main Street and the Public Square.

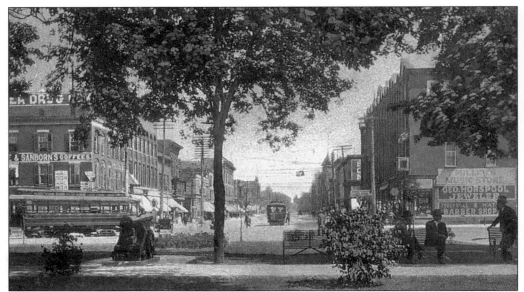

Main Street, East from the Square. This postcard, looking east on Main Street from the Public Square, shows a bustling community at the turn of the last century. The Spanish American War cannon is in its original location at the head of Main Street. The building at the corner on the south side of Main Street was known for many years as the Carr Building. It was razed in the 1960s, and since then has been the site of a savings and loan association. On the north side are a grocery and the Lescher Drug Company—later the Hawthorne Drug Store, familiar until the 1970s.

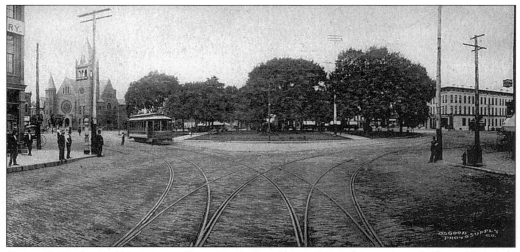

Central Park. Looking west from Main Street in 1907, this postcard shows Central Congregational Church to the south. To the north is the Union Hotel, which later became the Broadview Hotel. Streetcars and interurban trains shared the same tracks that circled around the square. Although there had been horse-drawn streetcars for some years, the first electric streetcars delivered passengers around town in 1892. As many as 24 streetcars criss-crossed the town at the turn of the century and carried passengers on to Knoxville.

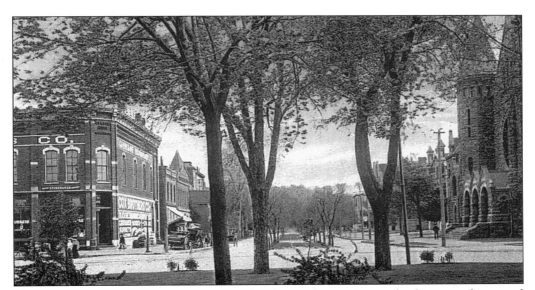

South Broad Street from Central Park. This is the 1908 view looking south toward Knox College. In this postcard, the trees that later formed a dramatic arch from the Public Square to the college are still rather small. It was a convenient path for the streetcars, which ran down the boulevard between the trees. Central Congregational Church is to the right, and the business in the building to the left sold farm equipment and buggies for many years. At the time of this card, the company was Cox Brothers, and later it was the Galesburg Implement Company.

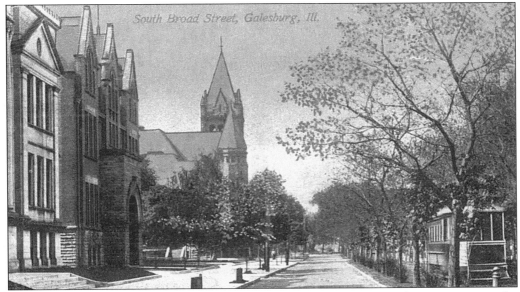

South Broad Street Toward the Public Square. This postcard shows a view to the north from the corner of Tompkins and South Broad Streets. To the left is the façade of the Galesburg High School and the red brick Central Primary School. The Central Congregational Church towers appear near the Public Square. Streetcars traveled south on Broad Street and on to Cedar Street and Academy.

Main Street at the Square. The businesses that faced Main Street—Foster's Photography Gallery, Miller's Music Store, and Ingersoll & Haitt Barbers—share the southeast corner of the Public Square. The town is decked out for the Golden Jubilee in 1907. The white pillar to the right and the bunting-wrapped kiosk were temporary. The White House and other saloons around the corner were more durable. That section of the block remained essentially unchanged until it was all demolished in the 1960s.

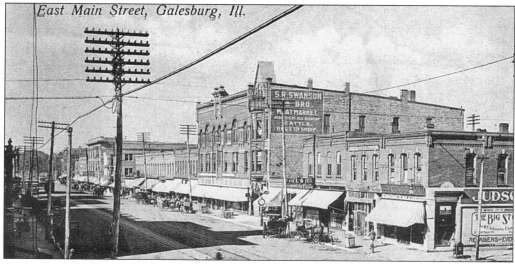

On East Main Street. Kellogg & Drake, a dry goods store established in 1889, occupied a large three-story building on the north side of Main Street, between Kellogg and Prairie Streets. Later the Kellogg & Drake at 227–235 East Main Street moved across the street, where it remained until the business closed in the 1960s. In the view above, advertisements painted on the side of Judson Hoover Drug Store also promoted O.T. Johnson's in the next block as "The Big Store." Swanson's Meat Market was the business in the narrow building with the decorative façade.

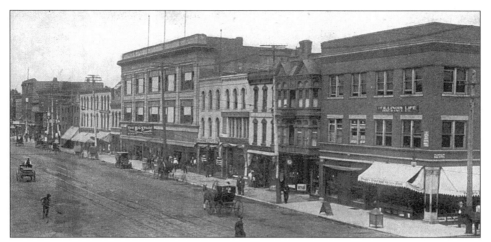

Main Street on the North Side. This photo depicts the north side of Main Street from Prairie Street west to the Square. The People's Trust and Savings Bank (right) shares the corner building with the Illinois Life Insurance Company and other professional offices. The large, three-story Big Store (O.T. Johnson's) is visible in the middle of the block. Also in the block are several buildings which were later removed in favor of more modern ones. The man in the lower left sweeping the street reminds those of us in the twenty-first century that in 1900, there would have been a lot of sweeping up—not only a nicety, but a necessity.

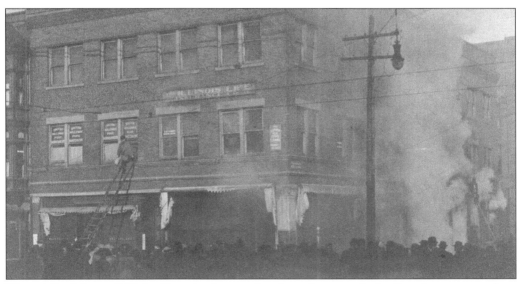

Fire at Prairie and Main Streets. A crowd gathered to watch the fire that occurred on December 11, 1910, at the corner of Prairie and Main Streets. Wood and Felt Grocery at 149 East Main Street and People's National Bank at 153 East Main Street were heavily damaged. Newspaper accounts tell of a daring rescue of an uninsured x-ray machine, and a man can be seen in this image escaping from an upstairs window. Apparently during the fire, a phone rang inside the bank. The bank president, with remarkable devotion to duty, returned to the burning building to answer a woman who called to inquire if her money was burning up.

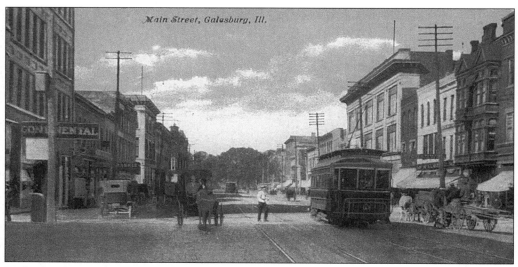

Main Street Looking West from Prairie Street. One of Galesburg's oldest businesses, the Continental, opened on the Square in 1895. Since that time, the Little and Burns families have been selling men's clothing. This view shows the Continental's second location, at the southeast corner of Main and Prairie Streets. In the 1960s, the Continental moved across Main Street and remained there for nearly 40 years. The most recent move has been to East Simmons Street.

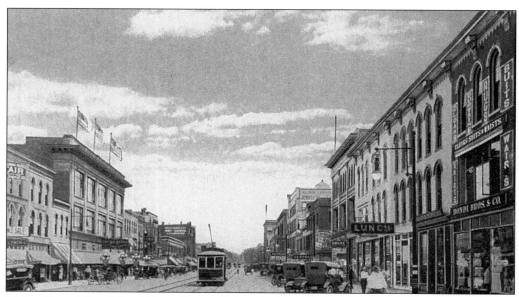

Main Street Looking West Toward Seminary Street. Galesburg's business district stretched to the west on Main Street from Chambers Street. The cupola of the Odd Fellows Hall at the corner of Seminary and Main Streets is to the right on this postcard. The Odd Fellows constructed this building in 1895, and it has been recently remodeled and updated for use as an antique mall. The tower on the south side of Main Street is that of Stamm's, a clothing store. The building remains today, but the tower and curved façade have been removed.

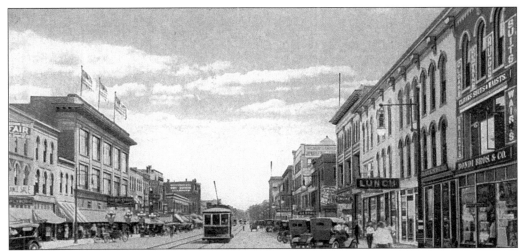

Main Street, East from Cherry Street. Flags fly above O.T. Johnson's on the north side of Main Street between Cherry and Prairie Streets. Bondi Brothers and Company is on the south in this view during the first part of the 1900s. The Bondis opened their ladies clothing store in Galesburg in 1897, at Cherry and Main Streets. The business was sold in 1927 to Klines, who later occupied the first floor of the new Bondi Building. Klines sold ladies clothing for another 50 years or so in that location.

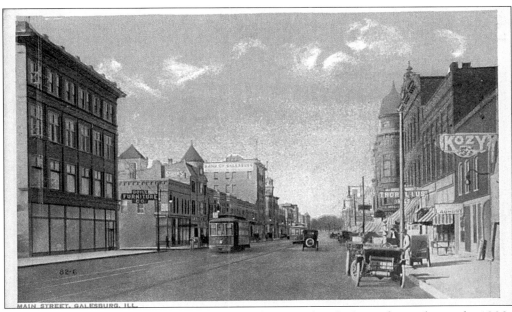

Main Street, East to West. This postcard view of Galesburg from the early 1900s shows the four-story Doyle Furniture building at the corner of Main and Seminary Streets. Along the south side of Main Street, to the west of Seminary Street were Dopp Hardware, Stamm's clothing store, and the tall Bank of Galesburg. Barely visible is the tower of the Illinois Hotel at Kellogg and Main Streets. On the north side, the sign for the Kozy Fruit Store hangs out over the sidewalk. The tower of the Odd Fellows building can be seen at the corner.

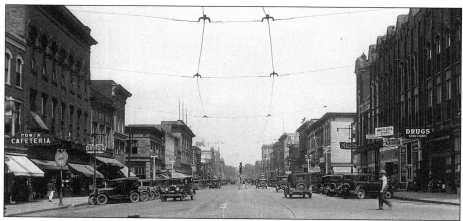

Main Street from the Square in the '20s. The commercial area in Galesburg was a busy place, and in order to control traffic, a stoplight was placed in the middle of the Main and Cherry Street intersection. Still, in 1923, city officials sought to stop traffic jams in Galesburg—not on the streets, but on the sidewalks. It seemed that too many people were stopping to talk to one another on Saturdays, simply to gossip, or as the newspaper speculated, "to settle many of the world's problems." Those with important business could not pass by. The large building to the left is Lescher Drug Company, and the one on the left was known as the Carr Building. The overhead cables power the streetcars.

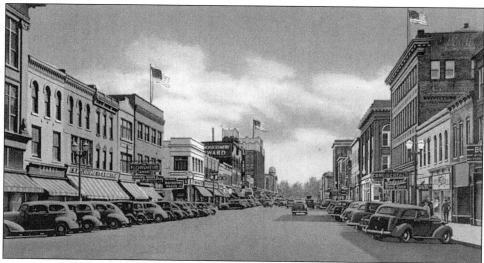

Main Street Looking East. This postcard was made from a photo taken by Charles Fach (1900–1993). Mr. Fach operated the Illinois Camera Shop on the first floor of the Weinberg Arcade from 1922 to 1966. He produced many of the photos that were published as local postcards. Once in the hands of the publishers, it was not uncommon for photos to be manipulated. Visually offending trash cans or distracting power lines were removed. Perhaps even a street full of absolutely identical cars were added to the scene. All these things were done with the interests of improving the looks of the town.

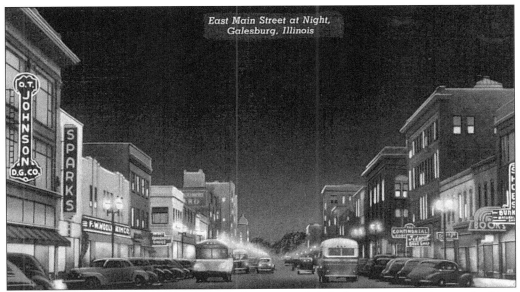

East Main Street at Night. Time marches on and Galesburg remained proud of her business district. This postcard, produced probably in the 1940s, shows a prosperous community—never mind that the publishers have romantically airbrushed out reality. O.T. Johnson's, Sparks Shop for Ladies, F.W. Woolworth's, and the Continental are open for business. Farther down the block on the north side is the Bondi Building and the tower of the Odd Fellows Building.

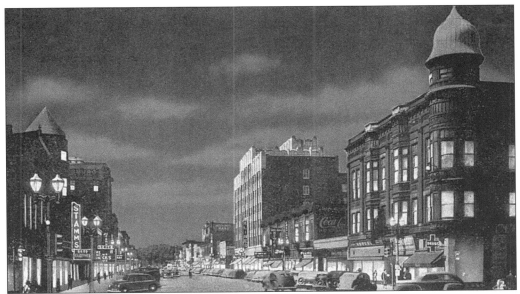

Main Street, from Seminary Street. The sun sets on a downtown full of activity. Looking to the west from Seminary Street, this postcard shows a town open for business on a Saturday night. The Odd Fellows Building and its copper-clad tower on the corner are alive with light. The Bondi Building is visible at the next corner. Across the street, Stamm's clothiers and the Alcazar pool hall are ready for customers.

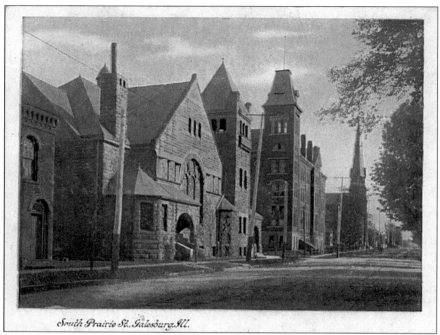

South on Prairie Street. In this pleasing view south on Prairie Street from Simmons Street in the first decade of the nineteenth century, one could see divergent elements of the religious spectrum. The Universalist Church on the corner supported Lombard College (called the Illinois Liberal Institute when it was founded in 1852) and the denomination's theological seminary. In the next block is Corpus Christi Lyceum, and in the distance, the largest Catholic church in Galesburg—Corpus Christi.

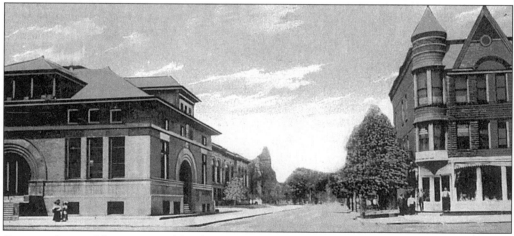

Coyner Store. This postcard looking west shows the corner of Simmons and Cherry Streets in about 1910. The post office and public library share the block to the right in this view. The tower of Churchill School can be seen down Simmons Street to the west. On the corner is the Coyner store at 90 South Cherry Street, where W.R. Coyner operated a drug and cigar store. Later it was Bower's Drug Store, and it was removed in the 1960s.

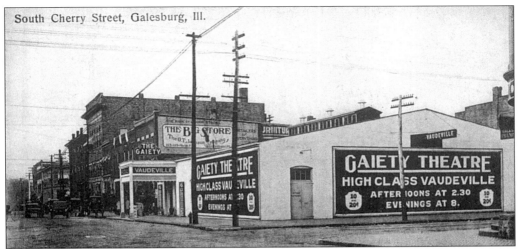

Gaiety Theatre on South Cherry Street. When the Gaiety Theatre opened across from the Coyner store in 1906, it offered only "high-class" vaudeville in two performances daily. General tickets were 10¢, and high-priced evening seats were 25¢. One of the opening acts was Charles Inness, "the Galesburg boy," who was warmly received. The Gaiety joined the Bijou, another vaudeville theatre on North Prairie Street, the Nickeldome Nickelodeon, which was also on Prairie Street, and the Auditorium Theatre on Broad Street, where stage productions were performed. The photographer was standing on Cherry Street facing north to take the photo for this postcard.

Chambers Street. During the first half of the twentieth century, Galesburg was a town distinguished by its trees. The efforts of the Galesburg Municipal Improvement Society and John Van Ness Standish (1825–1919) that were begun in the 1890s were now apparent. A deliberate plan to plant trees along the streets rewarded generations. Many remember with nostalgia riding on a hot day in summer through cool tunnels of shade. The trees that arched above were mostly elms, and they created a quiet, cathedral effect along the streets of Galesburg. Disease hit the elms in the 1960s, and, as one sad poet said, the town "rang with the sound of chain saws."

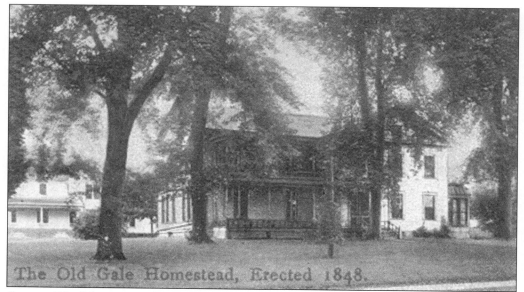

George Washington Gale's House. The founders settled first at Log City, near what is now Lake Storey. Log cabins were not permitted within the city limits, because the New York settlers wanted a town that looked prosperous and well-kept from the beginning. Such was the house that town and college founder George Washington Gale (1789–1861) built in the 1840s for himself at 127 East North Street. Additions have been made to the Greek Revival-style house, but changes in ownership have been few. In 160 years, members of only one other family—Tryon—have owned the house.

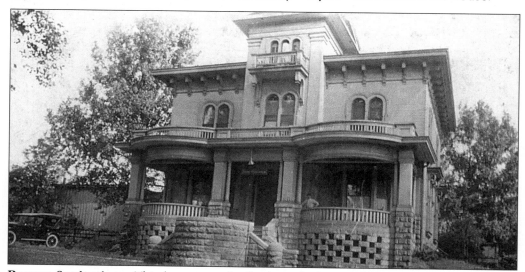

Barnes Sanitarium. This house was built around 1889 at 527 West Main Street, near Maple Avenue, by a furniture dealer and undertaker, A. Dean. Later it was remodeled substantially. The stone porch was added, and Dr. C.A. Barnes converted the house to a chiropractic sanitarium which he operated for nearly ten years. The building managed to house as many as six families at one time in the 1920s, and in the early 1930s, it was razed.

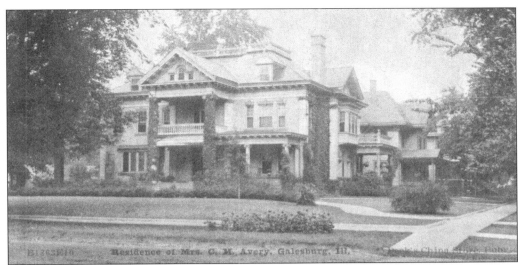

Avery/Ingersoll House. Cyrus Avery (1846–1905), who had developed and manufactured corn planters and stalk cutters, built this impressive house at 640 North Prairie Street in 1902. Reeves and Ballie, architects from Peoria, designed the house that became known as the "Bee Hive." Later the house was sold to Stephen A. Ingersoll (1853–1936), another local industrialist, founder of Coulter Disc Company. In 1946, the house was sold to Knox College, and it has since served as the residence for the college president.

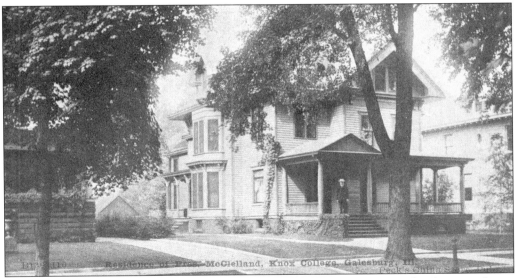

McClelland House. The house at 656 North Prairie Street was the home of two generations of the McClelland family. Thomas McClelland (1846–1926) was the president of Knox College from 1900 to 1917, and his administration was characterized by high academic standards and increased endowments. His son Kellogg McClelland (1884–1967) was devoted to Knox, and from 1915 to 1961, he was the college treasurer. The property was transferred to the college at his death and remained in college hands for nearly 20 years.

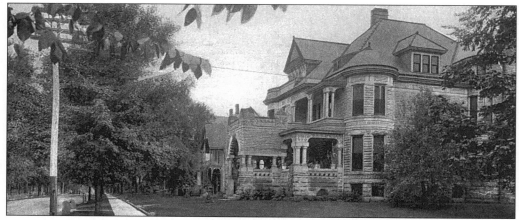

Lawrence House. George Lawrence (1859–1934) was a gentleman farmer, lawyer, and as they often said at the turn of the century, a capitalist. In 1891, he invested considerable capital, $80,000, in the construction of his house at 590 North Prairie Street. The house, then and now, is a showpiece of elegance. Designed by Galesburg architect William Wolf, the exterior is made of white corona sandstone. Given as a gift to the local schools by George Lawrence's daughter, Rebecca Lowrie, the house served as the administrative offices of the local school board. Since 1982, the house has been in private hands.

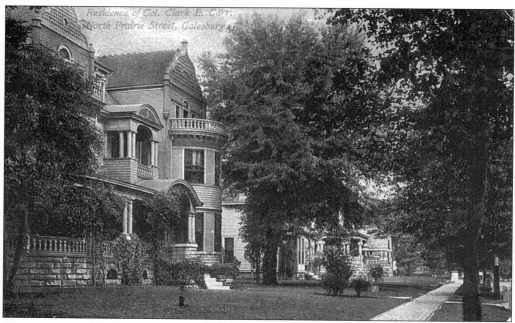

Clark E. Carr House. William Wolf (1838–1906) was the architect of the residence at 560 North Prairie Street. The house was built by Clark E. Carr (1836–1919) after he returned from a diplomatic assignment in Denmark (1889–1893). There was no question that Clark Carr was an important man around the town—he was a lawyer, local newspaper publisher, postmaster (1861–1885), author, staunch Republican politico, and, as he liked to say, a friend of Abraham Lincoln.

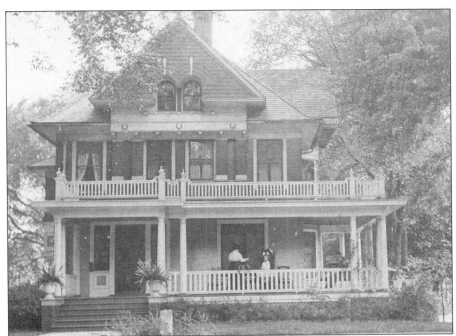

Henry F. Willis House. The house at 110 East North Street was the home of Henry F. Willis (1854–1918), a partner in Willis Manufacturing. Still in operation today, Willis Manufacturing began producing galvanized cornices and storefronts, fireproof doors, commercial skylights, and even an iceless refrigerator. The Willis house remains standing today, but like many houses of its era, has been modified and modernized. Much of its charming architectural detail is gone, and the street has encroached on the yard.

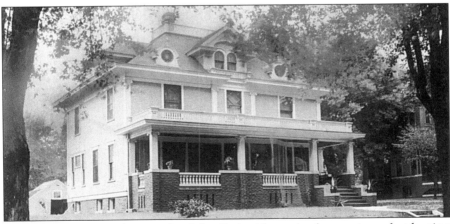

E.O. Burgland House. The Burgland family had been in the meat market business for decades by the time this photo of 580 North Seminary Street was taken. Edward O. Burgland, who constructed this house and the two houses to the south as well, was a partner in Burgland and Burgland Meat Market, offering "Home-Killed Meats at Reasonable Prices." Burgland and Burgland was in operation at 106 East Main Street until the late 1930s.

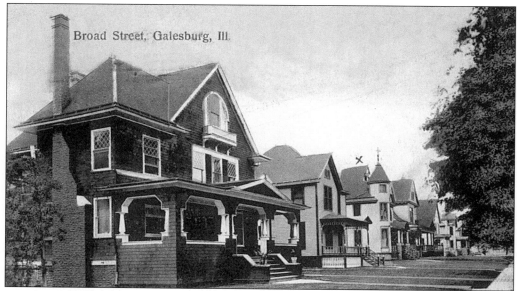

North Broad Street. The 1100 block of Broad Street is one of Galesburg's most inviting residential areas, and today it looks very much the same as it did in 1905. Spacious lawns and houses typical of the day were characteristic of many of the town's neighborhoods. Carpenters, implement dealers, and college professors lived on this block. The house to the left was that of Judge J.D. Welsh, and next door was Perry Anderson's widow, Kate. The "x" marks the house that was owned by Dr. W. E. Mabee, a local dentist.

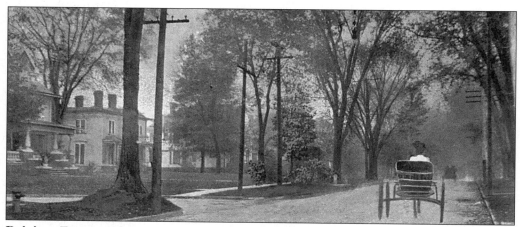

Driving East on Losey Street. This postcard, looking east on Losey Street from Bateman, shows just the sort of peaceful elegance that characterized Galesburg in the early part of the twentieth century. Galesburg was a town full of large houses, wide lawns, and shaded streets. The first house on the left still stands at the corner, at 485 East Losey Street. It was built by S.R. Swanson, who operated a meat market on Main Street. Next is the house built by Galesburg pioneer, Silas Willard (1814–1857). A subsequent owner added the large white pillars to the house, and since then the house has been a commanding sight at the head of Chambers Street. Today it is a residence and bed and breakfast at 501 East Losey Street.

Nine
Galesburg Is The Place To Be

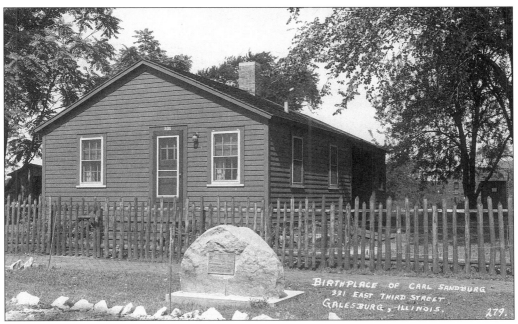

Carl Sandburg's Birthplace. Carl Sandburg (1878–1967), the son of Swedish immigrants, was born in Galesburg. His passion for education and his creative spark were awakened at Lombard College. As a poet, biographer, historian, journalist, and minstrel, Carl Sandburg developed a reverence for people and their struggles. His work, poetic and historical, celebrates the accomplishments of the common person, and ultimately won him the Pulitzer Prize. His ashes, along with those of his wife Paula, are buried beneath Remembrance Rock at the site of his birth—331 East Third Street, which is now an Illinois State Historic Site.

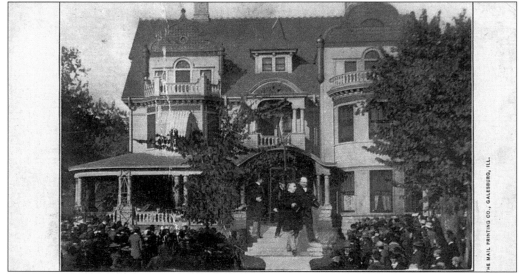

President McKinley at Carr House. President and Mrs. McKinley stayed at the Clark E. Carr house at 560 North Prairie Street when they visited Galesburg in October 1899 for the Lincoln-Douglas Debate Celebration. This clearly-manipulated postcard celebrates that event. (Note how the very large figures of President McKinley and Clark E. Carr have been superimposed on the porch.) The president was accompanied by various cabinet members, and a legendary tale developed that a cabinet meeting was held at the house—supposedly the first ever to be held outside of Washington, D.C. The cabinet meeting may have occurred, but the truth is lost to history.

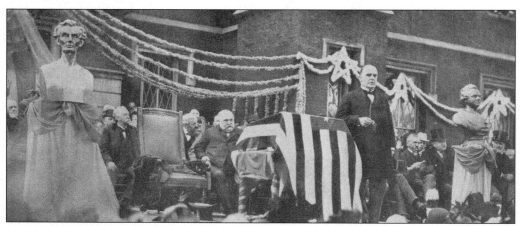

President McKinley Speaks at Knox College. Flanked by busts of Lincoln and Douglas, President William McKinley spoke at Knox's Old Main to commemorate the 40th anniversary of the great debates. Clark E. Carr (1836–1919) is seated behind the podium. To have the president and so many of his advisors gather here was quite an honor, and these postcards were printed to spread word that Galesburg was the place to be. This photo was taken by one of Galesburg's finest photographers, Allen A. Green (1880–1963). Enterprising and creative, Allen Green wrote poetry and children's books illustrated with his photos. He was an inventor and conservationist as well. In the early 1900s, he moved to Iowa and developed a 7,000-acre nature preserve.

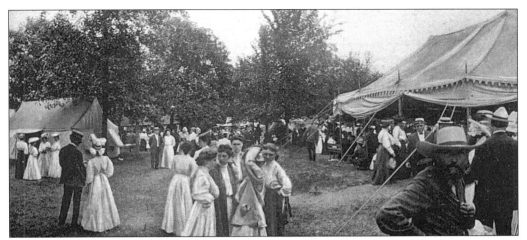

Chautauqua Grounds in Galesburg. The movement that started in New York State in 1874 at the Chautauqua Institution arrived in Galesburg in 1898. The first Chautauquas were held at Lake George (now Lake Rice), and later moved to the area called Highland Park, more recently known as Gale Lake. The Chautauqua lasted for a week or more, and developed into a mix between a camp meeting, a music festival, and a lecture series. Notable speakers and entertainers came to Galesburg to perform, and then moved on to the next Chautauqua town scheduled on the circuit. A tent large enough to seat 2,500 was erected, and each year there were optimistic plans to eventually construct a coliseum. Chautauquas were held in Galesburg into the 1930s, but the coliseum never became a reality.

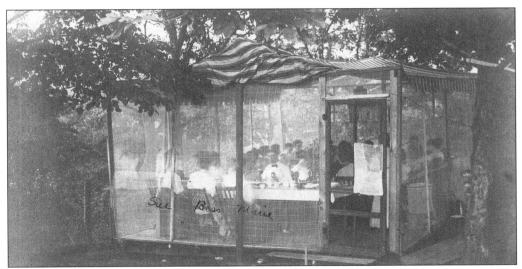

Chautauqua Lunch Tent. A season ticket for the entire week was $1.50, and at Highland Park, tents (with floors) rented for $4 for the week—more if you wanted cots. Furniture was brought out from town, and restaurants provided meals in their own tents on the Chautauqua grounds. The streetcar line came right out Main Street, which was convenient for those who came out for the day or for the whole session. There was space for horses, feed at a nominal rate, and plenty of good water for those who brought their own transportation.

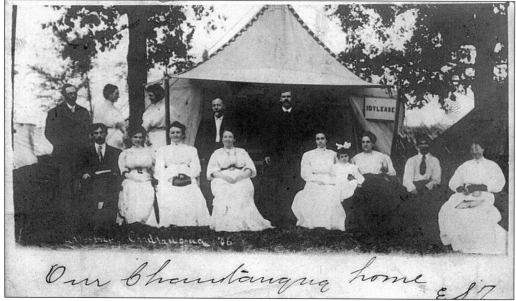

Idylease at Chautauqua. This 1906 group gathers in front of their tent, which they have named "Idylease" for the week. Newspapers printed the names of those "tenting" for the week, and many came from the small towns in Knox and surrounding counties. The Chautauqua brought the world to a population that was eager for information about science and politics. Riding on good times, people were ready to laugh and to learn. The schedule of events for 1900 promised, "We furnish you rest for the body, food for the mind, and grace for the soul in 12 star days."

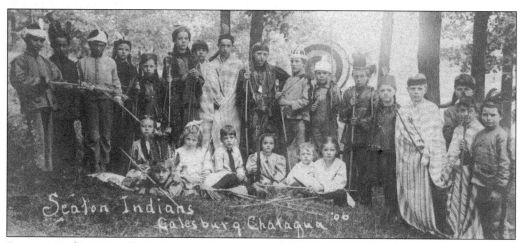

Seaton Indians at Galesburg Chautauqua. The author of this card, Ethel C., says, "Dear Hazel, This is one counsel meeting." At the 1906 session, the children were gathered every morning to engage in Indian activities. They adopted Indian names and played games. Bow and arrow drills were scheduled in the afternoons, and pow-wows complete with council fires were scheduled for the evenings. The Chautuaquas were a family event. Activities were provided for children so that mothers could partake of the events during the day, or, as one article suggests, just rest.

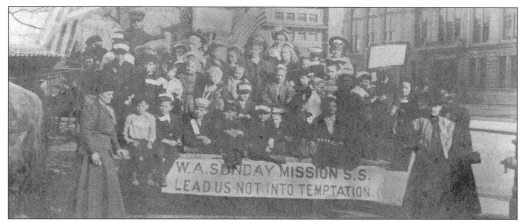

Sunday Support. W.A.Sunday—the famous Billy Sunday—came to Galesburg several times in the first part of the 1900s to evangelize for Jesus, and to save all from the evils of drink. A "tabernacle" was set up between Hope Cemetery and the Public Square, which was packed every night. One witness gave the following account: "The tabernacle was jammed. Those fortunate enough to have seats were right on the edge of them. Billy was in fine form—he took us down to hell and then up to heaven, and we came back to Galesburg a-whooping and a-hollering as though we'd engineered the trip ourselves." This group supporting Billy Sunday's Mission Sunday School stands in front of the public library on Simmons Street.

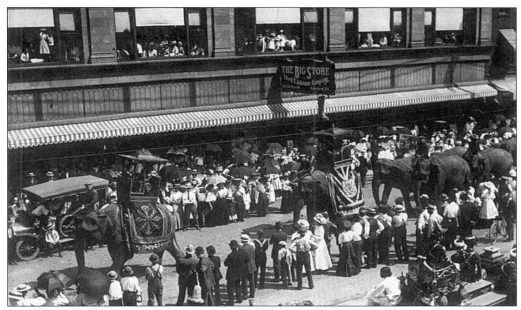

Elephants on Parade. Circuses were huge events in Galesburg. The circus train would stop at the east edge of town and unload. The troop would walk out Main Street to the circus grounds set up just outside of town. Later, a lavish parade down Main Street with the wild animals, performers, and musicians would announce the arrival of entertainment and fun. This undated postcard depicts elephants parading in front of O.T. Johnson's—the Big Store, at 125 East Main Street.

It's Only a Paper Moon. Among the street fair vendors of trinkets and pastries, acrobats and showmen, there were photographers, who created "postals" for the fairgoers on the spot. This rather anxious looking subject is sitting on a paper moon, which was a very common photographer's prop. His hopeful message in 1911 to Indiana reads "When this you see, just think of me. In the far west." The street fairs were popular with the community, but ironically many Main Street merchants complained of lost business during the fairs. The Union Hotel proprietor stated that people would opt for other hotels rather than stay at the Square, the center of festivities, noise, and music.

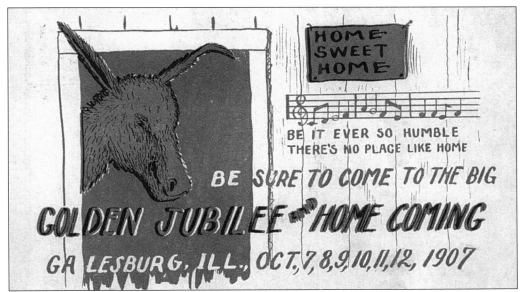

Golden Jubilee and Homecoming. The 50th anniversary of the incorporation of the City of Galesburg was cause for celebration. The Homecoming was called the greatest event ever in town. During the first week of October 1907, the town turned out for parades and street fairs, coronations, and a Billy Sunday revival. Performances up and down Main Street showcasing jugglers and aerial artists were the order of the day—even Rice's Big Trained Pig Show was part of the celebration! Perhaps most appealing may have been the flights of the airship operated by Capt. Horace B. Wild.

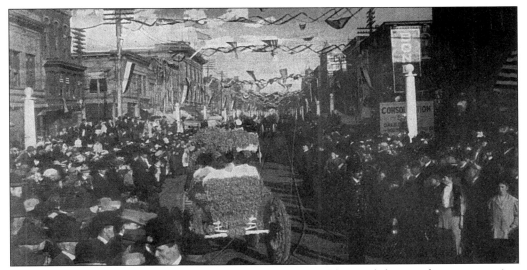

The Floral Parade. Parades were part of the Golden Jubilee and Homecoming celebration. A floral parade created a great deal of attention. Schools, businesses, and organizations decorated elaborate floats. The newspaper reported that thousands lined the parade route to see the pageant and the Homecoming Queen. Speeches, reminiscences, and reunions were scheduled as entertainment. The week-long event ended with a blazing pyrotechnic display on Main Street.

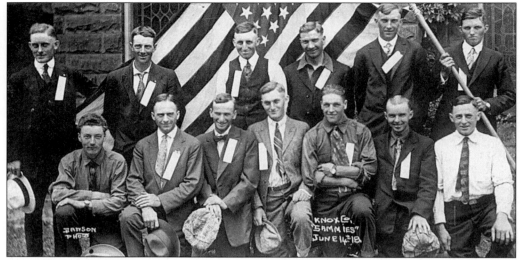

Sammies Go to War. The war was on. Knox County soldiers, known as "Sammies," were heading off to fight for Uncle Sam. Of the men who left Galesburg on June 15, 1918, some went to training school in Kansas City, and some to Camp Grant in Rockford, Illinois. There were monthly military quotas to be met. In Galesburg, there was also a push to get all men behind the cause. Local boards read the "work or fight" order to those who might be considered idlers in an effort to see that jobs on the home front were filled. World War I was felt at home too, and in 1918 there was no Fourth of July celebration for the City of Galesburg.

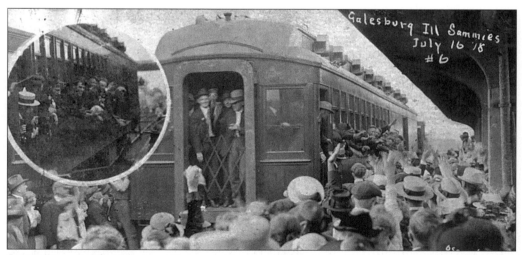

Sammies on the Trains. Troop trains came through Galesburg almost every day. Some stopped for refreshments served by the community, but even if they did not stop, the trains passing through town were reported in the newspaper. The war was news. When local boys went off to war, bands of musicians and hundreds of well-wishers crowded into to the depot to see them off. The papers carried not only the everyday news of the war events in Europe, but also local news of casualty lists, food and fuel shortages, the latest calls to arms, and letters from hometown men at the front. These men were headed for Camp Grant on July 16, 1918.

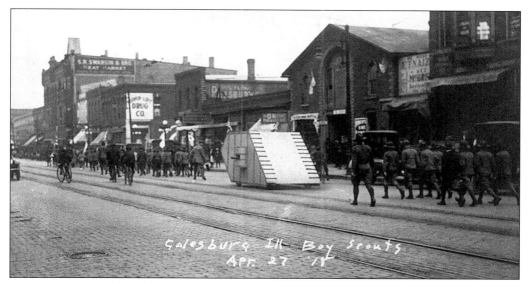

Boy Scouts Lead Parade. All the Boy Scout troops in Knox County staged a parade to support Liberty Bond Sale Day on April 29, 1918. A "tank" built by the scouts and mounted on a Ford chassis was lead down Main Street by the color guard and 150 Boy Scouts, sounding shots all the way. The scouts paraded back up Main Street, and parked the tank at the square. Over $12,000 was collected by the troops to support the war effort. In addition to the parade, this postcard shows the north side of Main Street at Kellogg Street, where the Bondi Building now stands.

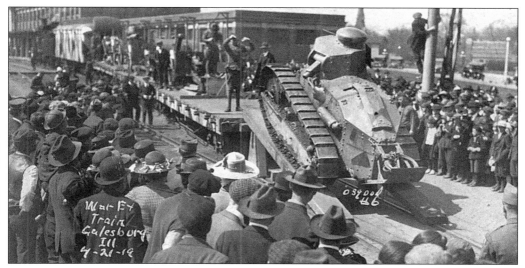

War Exhibit Train. At seven in the morning on April 21, 1919, the *Victory Loan Relic* train rolled into Galesburg. The Camp Grant Hospital Band marched out into the town playing loudly to announce the arrival of the train. Shortly, thousands were at the depot to see the Whippet tank and other French, American, and German war armaments. Speeches were made by politicians and former soldiers alike in an effort to encourage donations to a fund to bring our boys home. Before noon, the train headed off to Oquawka.

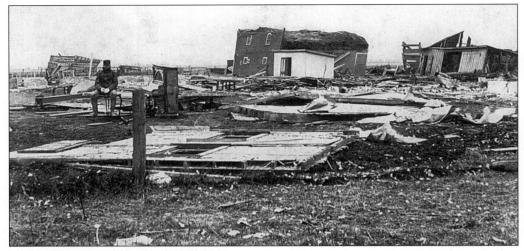

Cyclone in the Midwest. The wind came up suddenly on March 28, 1908, and what can only be called a cyclone danced across Warren and Knox Counties. The newspaper reported that near Coldbrook "Mrs. Murdock was precipitated into the basement" as her 14-room brick house collapsed around her. Barns and houses alike collapsed. Trees were uprooted. George Lawrence on North Prairie Street lost a big maple, and Mrs. Boggs' barn at 468 North Broad Street was lifted off its foundation. The author of this card said, "Thought for sure it was going to squash in the windows where I was." This house had been west of Galesburg.

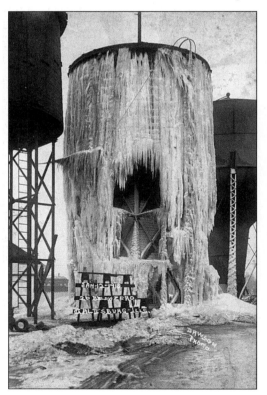

Ice Cold Water Tank. A severe cold snap in January 1918 was too much for this water tank. The headlines read "Galesburg Now Snowbound and Very, Very Cold." A continuous blizzard and 26 degrees below zero temperatures, as reported on this postcard, caught the town and the whole Midwest in a serious storm. Trains were stranded all across the state. The depot was "a rendezvous for the freezing and a haven for the belated." The newspaper reported that a blocked passenger train from Peoria provided a poor hotel. "Two engines at the rear attempting to butt it on its way disturbed the slumbers of the passengers." The snowstorm and cold were further complicated by a coal shortage in town. Coal yards ran short, and the streetcars were stopped to conserve fuel.

Snow Storm in Knox County. In the afternoon of February 7, 1936, the temperatures started falling, and then it began to snow. Roads were blocked, and towns were entirely cut off. There were four snowplows in the county, and two of those were disabled in the snow. Another was inoperable. Trains were stalled in the monumental drifts along the tracks. On one train, passengers helped the train crew with shovels to free the train. The day after the storm, an enormous drift nearly 20 feet deep and over a mile long, was cleared near Altona when snowplows and teams of men shoveling from both ends broke through. Even then the traffic was just one-way for miles. As in other such storms, the major concern was the coal supply to heat homes.

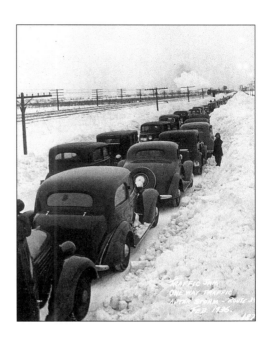

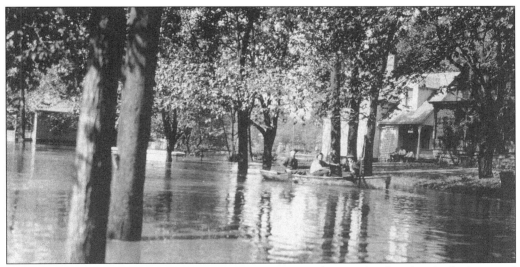

Flood on Peck Street. Torrential rains in June 1924 caused a flood, which damaged property and crops in Knox County and put the city water works out of commission. Cedar Fork overflowed with some regularity in the early part of the 1900s, and here it has filled Peck Street at Seminary Street. During this flood, the creek was a block wide at several places. Rail service on both the CB&Q and Santa Fe were halted due to the washouts, and the city's fire engines were used to pump water from the basements of the power plant and the phone company. After this flood, efforts to control Cedar Fork were initiated.

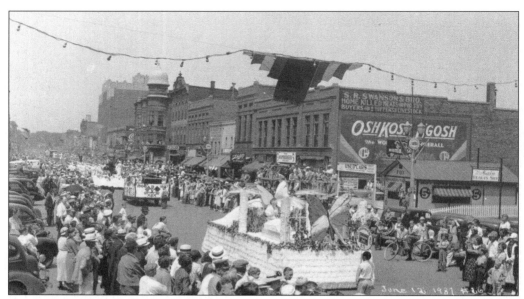

Centenary Parade Down Main Street. In 1937, both Knox College and Galesburg celebrated their 100th anniversary in a year-long festival. There were nationwide broadcasts of speeches and historical readings. In June, there was a gala parade which was attended by a reported 20,000 people. It was an imposing spectacle, which the newspaper said "tied up history with the present." Clubs, fraternal organizations, schools, and merchants built floats. Bands and military groups marched. The CB&Q Railroad provided a display nearly a half-mile long with 33 units.

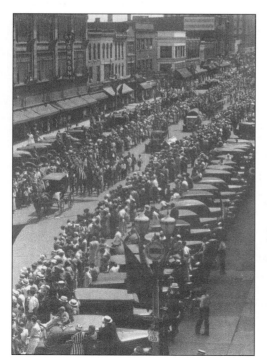

Centenary Parade. The Centenary celebration included musical performances, amateur shows, and an enormous community dinner at the armory. After the June parade, a pageant was performed at Lake Storey. "The Masque of Prairie Pioneers" told the tale of the founding of the town and the college. The presentation included a cast of 360 people, as well as livestock and horses. The program concluded with a fireworks display. In the dramatic finale, an 1837 log cabin was depicted in fireworks, which then melted away to be replaced by the image of Old Main.

Those Were the Days. The hubbub was about a real-live Hollywood movie, *Those Were the Days*. Its gala world premiere was held in Galesburg in May 1940, complete with huge searchlights and visits from stars. The film was based on the very popular books by Knox College alumnus, George Fitch (1877–1915). The Siwash stories were about turn-of-the-century collegiate antics at the fictitious Midwestern school called Old Siwash. Starring William Holden, not to mention Knox students as extras, the movie contained many scenes filmed in Galesburg. This postcard celebrated the time period of the movie with vignettes of the Galesburg of 1904.

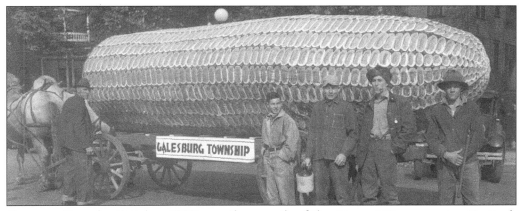

Corn on Parade. October 1937 was the month of the Harvest Homecoming Festival. The celebration was a county-wide affair, and individual townships were proudly represented in the parade, which included bands, floats, and a tribute to King Corn's Birthday—complete with cake. Other festival events were a style show, a street fair with rides and amusements, the Lincoln-Douglas Debate reenactment, and the rededication of the Galesburg airport on Henderson Street at Dayton Street.

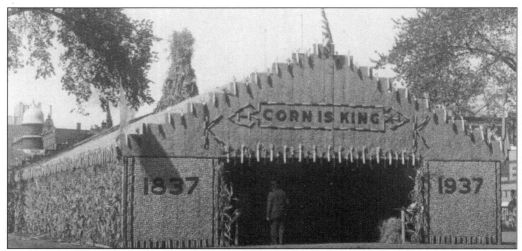

Corn Palace. Not unlike the glorious structures of some other Midwestern states, Galesburg boasted her own Corn Palace at the Harvest Festival of 1937. Set up on East Main Street near the post office, the building was cleverly decorated on the exterior with varieties of colorful corn. Inside, each township was represented with exhibits of ingenious agricultural enterprise—home-owned electric power plants, a 15-foot corn stalk, a 15-inch sunflower, the first mill in Wataga in miniature, and a "cabin made cleverly from corn cobs."

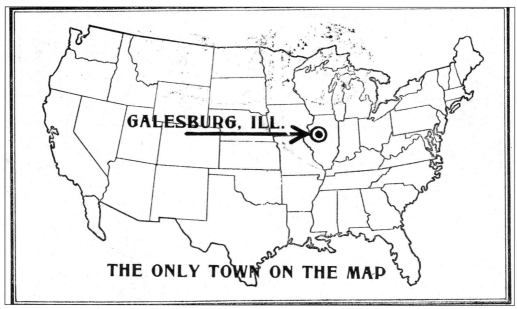

Galesburg Makes the Map. It is plain to see that in the whole United States, Galesburg, Illinois, is the place to be. Originated with dreams and determination, Galesburg developed into a community of enterprise and invention. The town maintained its faith, survived losses, promoted its educational institutions, and developed an atmosphere of commerce and industry. Galesburg is a town with a history as well as a future. It is the only town on the map.

Abolitionism, 30, 74, 86
Acme Milling Co., 58
Aerial views, 6, 11, 13
Aldrich, Harry G., 21
Aldrich, Norman K., 24, 35, 73, 76, 78, 82, 96
AME Church, 31
American Beauty restaurant, 56
Anderson, Oscar, 96
Anderson, Mrs. Perry (Kate), house, 112
Auditorium, 45
Avery, Cyrus, house 109
Bank of Galesburg, 43,46, 103
Barnes Sanitarium, 108
Beadle, J. Grant, 17, 22, 34, 43, 52, 73
Beecher, Edward, 16, 74
Beecher Chapel, 32, 74
Bengston, Ruth Dahlberg, 79
Bickerdyke, Mary Ann (Mother), 16
Big Store, see O.T. Johnson Co.
Blockinlinger, E.C., 53
Bohrod, Aaron, 21
Bondi, Isidor, and Hart Bondi, 51
Bondi Building, 51, 102, 105
Boy Scouts, 121
Boyington, W. W., 37
Broad Street, 45, 99, 112
Brown, George W., 43, 94
Brown Cornplanter Works, 10, 11, 77
Brown's Business College, 10, 36, 48
Burgland, Edward O., house, 111
Business development, 13, 14, 44, 61, 91
California Zephyr, 69
Cannon, Spanish-American War, 16, 98
Carr, Clark E., 72, 110, 114
Carr Building, 98, 104
Catherine Club, 90
Centenary celebration, 124
Central Congregational Church, 6, 10, 22, 73, 74, 98, 99
Central Park, 97, 98
Central Primary School, 22, 99
Chambers Street, 107
Chautauquas, 115-116
Cherry Street, 17, 19, 107
Chicago Burlington & Quincy Railroad, 6, 7, 10, 11, 13, 61, 62, 63, 64, 65, 68, 94, 124
Churches, 9, 24, 73-86;
 see also names of specific churches

Churchill, G.B., 49
Churchill, George, 22
Churchill Hardware Store, 49, 89
Churchill School, 6, 10, 22, 106
City Hall, 11, 17
Civil War, 16, 26, 40, 86
Commercial Block, 36, 48
Continental Clothing Co., 50, 102, 105
Corpus Christi Church, 10, 24, 83, 106
Corpus Christi High School, 11, 24
Corpus Christi Lyceum, 10, 78, 84, 106
Costa, Father Joseph, 83
Cottage Hospital, 11, 23
Cottos, Nicholas, 56
Cox Brothers, 99
Coyner store. 106
Cracraft, Rev. J.W., 86
Crown, Jimmie, 75
Custer, Omer N., 43, 44, 55
Davis, George, 34
Denver Flyer, 62
Dolly, 70
Douglas, Stephen A., 30
Doyle's Furniture Store, 51, 103
East Main Congregational Church, 75
Education, 22, 31;
 see also, names of specific schools
Fach, Charles, 104
Faith United Methodist Church, 81
Female Seminary, 30, 31
Ferris, Sylvanus, 7
Field, Eugene, 14
Fire fighting, 18, 19
Fire station, Central, 10, 17, 18, 36, 48
Fires, 18, 19, 22, 37, 42, 50, 57, 58, 59, 63, 76, 77, 81, 101
First Baptist Church, 31, 76
First Christian Church, 82
First Congregational Church, 74
First Lutheran Church, 79, 80, 81
First Methodist Episcopal Church, 77, 78
First Presbyterian Church, 73
Fitch, George, 125
Fraternity Building, 46
Gaiety Theatre, 107
Gale, George Washington, 7, 108
Gale, W. Seldon, 72
Gale Lake, 94, 115
Galesburg and Great Eastern Railroad, 70
Galesburg Armory, 21

Galesburg Boosters, 91
Galesburg Club, 11, 20, 91
Galesburg High School, 4, 22, 32, 99
Galesburg Hospital, 23
Galesburg National Bank, 50
Galesburg Opera House, 50
Galesburg Women's Club, 90
Giant Mill, 96
Golden Jubilee, 100, 119
Gottchalk, Charles E., 73
Government Building, 20
Grace Episcopal Church, 86
Green, Allen A., 114
Grocery stores, 18, 53, 98, 101
Hansen, H.L., 96
Hanson, Adolph, 79
Harrison, Benjamin, 33
Harvest festival, 125, 126
Hasselquist, Tuve N., 79
Hawthorne, Stanley and Stewart, 44
Hawthorne Center, 25
Hawthorne Motel, 44
Highland Park, 94, 115
Hill, Henry C., 43
Hinchliff Lumber Co., 57
Holmes Building, 50
Homestead Room, 55
Hope Cemetery and Abbey, 26
Horse and mule barn, 14, 59
Hotel Custer, 11, 43, 44, 55
Ideal American city, 13
Illinois Camera Shop, 104
Illinois Hotel, 43
Ingersoll, Stephen A., house, 109
Inness, Charles, 107
Jail, Knox County, 19
Johnson, Thomas E., 96
Johnson Fuel Co., 118
Judson-Hoover Drug Store. 100
Kellogg & Drake, 100
Kensington building, see Hotel Custer
Kitson, Theo, 16
Knox Academy, 22
Knox College, 7-8, 19, 27, 29, 30, 31, 32, 40, 74, 87, 99, 109, 124;
 Alumni Hall, 6, 33; East Bricks, 28;
 George Davis Hall, 11, 34;
 Gymnasium, 34; Memorial Gym, 36; Observatory, 32; Old Main, 2, 6, 11, 28, 29, 30, 114, 124;
 Seymour Hall, 34; Seymour Library, 11, 35; West Bricks, 28, 35

127

Knox Conservatory of Music, 30
Knox County Courthouse, 2, 10, 11, 15, 24
Knox Street Congregational Church, 75
Labor Day Parade, 118
Lake George, 115
Lake Rice, 4
Lake Storey, 2, 11, 96
Larkin, Edgar, 32
Lawrence, George, house, 110, 122
Lescher Drug Co., 98, 104
Lincoln, Abraham, 30
Lincoln, Robert Todd, 26
Lincoln Park, 95, 96
Lincoln-Douglas Debate, 26, 29, 30, 114, 125
Locomotives, 67, 69, 71, 72
Log City, 21, 108
Lombard College, 29, 37, 38, 39, 40, 76, 87, 106; Gymnasium, 37, 38, 39; Lombard Hall, 37, 38, 39; Old Main, 37, 39; Tompkins Hall, 38, 40
Lombard Elm, 40
Lombard Junior High School, 37, 38, 39
Lott's Drug, 54
Louie's Liquor, 54
Mabee, Dr. W.E., house, 112
Mail delivery, 20, 67, 70
Main Street, 6, 13, 98, 100-105, 121
Marsh, Leroy, 59
Masters, Edgar Lee, 32
May, Marvin H. and Delia, 9
Mayo General Hospital, 25
McClelland house, 109
McClure, S.S., 29
McKinley, President, 114
McKnight, J.T., 72
Meath railroad car, 71
Methodist Episcopal Church, 10, 31
Meyers, E.E., 15, 33
Mission Covenant Church, 81
Nelson, C. Atle, grocery, 18
O.T. Johnson Co., 20, 47, 100, 101, 102, 105, 117
Odd Fellows, 102, 103, 105
Old First Church, 73, 74, 75
Olson, Blanche, 53
Orpheum Theatre, 43, 45
Osgood, Charles, 41
Peck's China Store, 49
People's Bank & Trust, 46, 101
Phelans Dry Goods, 48

Photo manipulation, 12, 104, 105, 114
Pioneer Zephyr, 68
Post office, 10, 11, 20, 21, 106
Postcards, production of, 2, 8, 18, 118
Poulos, Paul, 56
Prairie Street, 106
Prince, George W., 16
Public library, 4, 10, 11, 19, 32, 106
Public square, 13, 42, 99, 100
Purington Brick, 60
Quayle, William, 19
Racetrack, 7, 88
Raeder, Henry, 64
Railroad, depots, 10, 14, 61, 62, 63, 64, 65, 72; yards, 6, 14, 64, 66; see also names of individual railroads
Rapp, George and C.W., 45
Rescue Mission, 85
Rowe Manufacturing Co., 57
Sandburg, Carl, 29, 37, 113
Sanford, Josephine and Sylvester, 85
Santa Fe Railroad, 11, 13, 59, 72, 96
Schimmel, Charles, 43, 55
Schools, 9;
 see also names of specific schools
Seminary Street, 18
Seymour, Henry M., 35
Seymour, Lyman K., 34
Simmons Street, 6, 36
Smithett, Rev. W.T., 86
Soangetaha Club house, 4, 94
St. John's Episcopal Church, 80, 86
St. Joseph's Academy, 84
St. Mary's Hospital, 11, 24
St. Patrick's Church, 83
Standish, John Van Ness, 39, 87, 107
Standish Park, 6, 32, 87
Storey, W.B., 96
Streetcars, 98, 99, 104
Sunday, W.A. (Billy), 88, 117, 119
Sunday, Mrs. Billy, 85
Super Chief, 72
Swanson, S.R., house, 112
Swanson's Meat Market, 100
Swedish language, 79, 80
Swedish Lutheran Church, 79
Swedough's, 54
Tennyson's Drug, 54
Theatres, 107,
 see also names of specific theatres
Thompson, G.W., 24
Those Were the Days premiere, 125

Transportation, 11, 14, 62, 68, 69, 70; see also names of individual railroads
Trinity Lutheran Church, 80
Tucker's Night Owls, 93
Ulrichson, Charles, 28
Union Congregational Church, 75
Union Hotel, 42, 98
United Brethren Church, 81
United Church of Christ, 75
Universalist Church, 4, 37, 38, 76, 106
Universalist Divinity School, 38
W.P.A., 21
Way to Knox, The, 27
Weather events, 122, 123
Weinberg, A.L. and Lafayette, 52
Weinberg Arcade, 52, 92, 93, 104
Welsh, Judge J.D., house, 112
Whiting Hall, 11, 30, 31, 32, 118
Wild, Horace B., 119
Willard, Silas, 61, 112
Williams, C.W., 88
Willis, Henry F., house, 111
Wing, E.D., 50
Wolf, William, 17, 45, 46, 48, 50, 76, 89, 110
World War I, 21, 120, 121
World War II, 25, 36
Y.M.C.A., 89
Young Men's Literary Society, 19
Zeldes, Louis, 54
Zephyr, 2, 67, 68